BRUSH WRITING

Calligraphy Techniques for Beginners

Ryokushū Kuiseko

KODANSHA INTERNATIONAL
Tokyo • New York • London

Photographs of calligraphy (cover and inside book), Katuhiko Hidaka.

Distributed in the United States by Kodansha America, Inc., 114 Fifth Avenue, New York, N.Y. 10011, and in the United Kingdom and continental Europe by Kodansha Europe Ltd., Gillingham House, 38-44 Gillingham Street, London SW1V 1HU. Published by Kodansha International Ltd., 17-14 Otowa 1-chome, Bunkyo-ku, Tokyo 112, and Kodansha America, Inc.

ISBN 4-7700-1362-0 (in Japan)
ISBN 0-87011-862-5 (U.S.A.)
LCC 87-82854
First edition, 1988
92 93 10 9 8 7 6 5 4

Contents

Foreword

"One hesitates for an epithet to describe a system of writing which is so complex that it needs the aid of another system to explain it. There is no doubt that it provides for some a fascinating field of study, but as a practical instrument it is surely without inferiors." Thus wrote the noted British Japanologist Sir George Sansom in 1928. Today the divergence grows ever wider between those who view the Japanese writing system as the written representation of a language, and those who venerate it as an almost mystical art form, inextricably bound to the culture, with the power to fascinate even when it is not understood.

On the one hand, Chinese characters in modern Japan are subject to a surprising amount of manipulation by forces far removed from the aesthetic. A new regulation imposed by the government can deprive a character of its prestigious position within the list of those approved for general use—to say nothing of revising its approved pronunciations. The computer-addicted segment of the Japanese population types away, using simple and regular romanized and syllabic writing systems that bypass characters, letting the machine produce the more abstruse Chinese-borrowed symbols. Serious empirical research into the nature of reading produces increasing quantities of data indicating that the Japanese—like everyone else—depend on subvocalization in their silent reading.

But the practical and pragmatic continues to be countered by the aesthetic and mystical. The beautifully drawn character, produced by a master calligrapher, is a work of art, unlikely to be associated with the output of a computer. Empirical evidence to the contrary, enthusiasts venerate these modern descendants of an ancient system, assigning values and powers and appeal far beyond the normal expectation for the symbols of a writing system.

It is for those who would like an introduction to the Chinese characters of the skilled calligrapher, with guidance from a master on what their skilled creation involves, that this book was written. As the newcomer to the system follows the required steps, any temptation to associate the procedures with traditional penmanship will quickly be abandoned. These are lessons in art—not writing, in the usual sense—but art constrained by a tradition that is centuries old. This combination of personal expression within a rigid framework of complex rules will pose an interesting challenge for the Westerner receiving instruction from Ryokushū Kuiseko through the medium of this interesting volume.

Eleanor Harz Jorden

Preface

This book is for the enthusiast rather than the specialist, for the specialist already has at hand any number of books dealing with his interests and concerns, whereas the enthusiast has virtually none.

Only after being a teacher for some time did I come to realize that the foreign students who came to me to learn the art of calligraphy were not isolated exceptions to the norm. Rather they were representatives of Western cultures who happened to have a keen interest in and a desire to understand the Oriental cultures of China and Japan. To the average Japanese, secure in the assumption that his culture is locked securely away from both the ignorant and the curious within an impenetrable linguistic strongbox, it comes as something of a surprise that non-Japanese should take any interest in the Japanese language. And that such a person's interest should extend into the complex intricacies of calligraphy is absolutely amazing.

Mysterious symbols curving and twisting across the page, black ink on white paper, these can have a fascination none the less powerful for their not being fully understood. Indeed, I would go further and say that it is precisely because one is unaware of their intent that these abstract shapes captivate the eye so strongly and are so obscurely beautiful.

In my experience, the complete newcomer to the Japanese writing system brings to this art an innocence and freshness that, paradoxically, may develop into an appreciation far deeper than that possessed by us who are thoroughly familiar with Chinese characters and use them daily for the purely mechanical purpose of communication.

And so this modest book is for beginners, for those with little or no knowledge of calligraphy, but who are nonetheless drawn to its beauty and power. In such inquisitive beginners we may perhaps discover—and then nurture—those elusive conditions necessary for the creation of beauty and art. This is my goal. If it is also yours, then this book is, most respectfully, dedicated to you.

While I have the opportunity, I would like to express my deepest gratitude to Mr. Gerard Houghton, lecturer at Nara Women's University, who painstakingly helped me to put together and revise the original manuscript. This was then given to Ms. Tamara MacGinty, English teaching consultant to the Kyoto public schools, who, with the assistance of Mr. Thomas Wright, Sōtō Zen priest and lecturer at Ryūkoku University, further refined the manuscript. I offer my heartfelt thanks for the efforts of all these people.

PART I

Chinese and Japanese Characters

The origin of Chinese characters is obscure and, as with many ancient things in China, shrouded in a curious mixture of myth and fancy. According to legend, this system of writing came into existence around 2700 B.C., the creation of a mysterious man with four eyes named Tsangh-hsieh, who was inspired by the footprints of birds and animals. Legend maintains that the god of Heaven was so impressed by this display of ingenuity that he caused grain to fall from the skies as a sign of his satisfaction with mankind.

More factual but less poetic evidence in archaeology consists of simple images engraved on pieces of oracle bone or tortoise shell and dating from the time of the Shang period (circa 1766–1122 B.C.). These images were the prototypes of the characters to come.

During the Shang period the Chinese people lived in fear of the awesome power of nature, which they believed to be controlled by Heaven. Heaven was the absolute being, and kings were its intermediators and proxies. Would the crops flourish or fail? Would the next day be a good one for hunting? Should war be waged or not? And what would next week's weather be? Kings referred all such questions, major and minor, to the heavens.

The inscriptions on bones and shells were, in the minds of ancient Chinese, a manifestation of the will of Heaven. First, several holes were made in the shells and bones, which were then exposed to a fire. The result was a cracking and splitting of the surface. These cracks were interpreted by priests, and the interpretation duly recorded on the bone or shell in the form of simplified pictures, the representations of the voice of Heaven.

Ultimately, the idea that pictographs were sacred and reserved for oracular utterances became fundamental to the development of Chinese characters into the intricate art of calligraphy. Even today, Chinese characters remain objects of reverence, virtual vessels of magic and power. They are venerable messengers from days gone by.

The Japanese imported the Chinese system of writing wholesale in the fourth and fifth centuries A.D. and adapted it to their own language. In fact, they still refer to these characters as *kanji*, literally, "characters [from] China." However, the Chinese and Japanese spoken languages differ greatly, which means that the pronunciations of particular characters also vary greatly. Sometimes even the meanings have diverged.

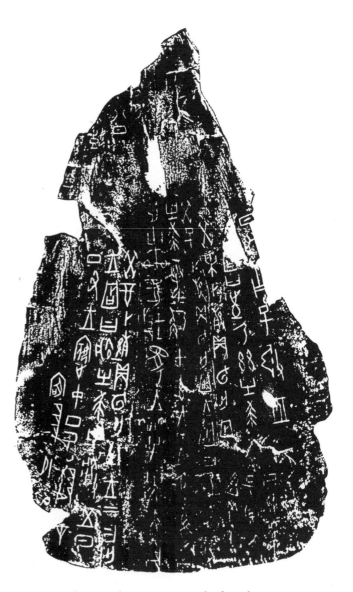

Chinese characters inscribed on bone.

Today, in both China and Japan, characters can be written in five different styles or scripts: Seal, Clerical, Block, Semicursive, and Cursive. Each script was devised to meet the demands of its time.

In order to indicate the nature of these styles, I will trace the origin and evolution of one Chinese character, 永. Its meaning is "forever" or "eternity" in both languages, and in Japanese it is pronounced *ei*. This character, when written in Block Script, is particularly convenient since it demonstrates the eight basic techniques found in all characters. In the heading for each section I have given the English name for each style followed by its Japanese name in parentheses, and then the Chinese dynasty in which it arose.

The character *ie* ("forever") inscribed on bone.

Seal Script (*Tensho*)
Qin Dynasty, 221–206 B.C.

At the beginning of the third century B.C. Shi Huangdi of Qin, known as the First Emperor, quashed the uprisings of the warring states and unified China. At the same time he organized and consolidated the writing of Chinese characters into what is known as the Seal Script. This script is well balanced and follows a rigid set of rules. It gives an impression of stability and grandeur, suggesting the solemn dignity of the Qin dynasty. Today the Seal Script is regarded as the progenitor of all Chinese characters. Its chief use is on ornamental seals and on seals impressed on works of art.

CHARACTERISTICS OF THE SEAL SCRIPT

- The thickness of the strokes is almost the same.
- The overall shape is rectangular, with a height-to-width ratio of three to two.
- The feeling is grave and expressionless.

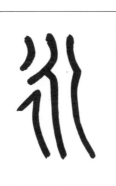

Clerical Script (*Reisho*)
Han Dynasty, 206 B.C.–A.D. 220

With the passing of time, writing came to occupy a very important position in society. Gradually the intricate Seal Script was considered too cumbersome for daily use, and the less complex Clerical Script was developed as a result. As the majority of officials came to use the Clerical Script, it was refined and became established, for all practical purposes, as the formal script of the Han dynasty.

CHARACTERISTICS OF THE CLERICAL SCRIPT

- One of the horizontal strokes of the character very often has a flip to the right that resembles breaking surf.
- The overall shape is rectangular, with a height-to-width ratio of two to three.
- The feeling is grave and refined.

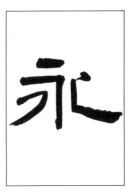

Cursive Script (*Sōsho*)
Han Dynasty, 206 B.C.–A.D. 220

The Cursive Script was invented as an informal means of writing all of the earlier scripts in a quick and abbreviated form. It was eminently practical. This script evolved gradually and became established as one of the informal styles of calligraphy during the Eastern Jin dynasty (A.D. 317–420). However, after many ages, its extreme simplification and lack of structured form made it difficult to read, and as a result it has been dropped from general contemporary use. On the other hand, its simplicity and diversity of shape lend it to artistic creation, and calligraphers still hold it in high regard.

CHARACTERISTICS OF THE CURSIVE SCRIPT

- The entire character is written with one stroke of a heavily loaded brush.
- The movement of the brush is rhythmical and fluid.
- Its outstanding features are simplification and diversity of shape.

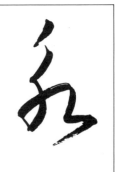

Block Script (*Kaisho*)
Three Kingdoms, A.D. 220–64

Born as an abbreviated form of the Seal and Clerical scripts during the Three Kingdoms period, the Block Script evolved into a uniform, ordered, and graceful style during the Tang dynasty (A.D. 618–907). Unlike the Cursive and Semicursive scripts, it followed a rigid set of rules that facilitated reading and writing. For these reasons, both in China and Japan, it has maintained its position as the formal style from the Eastern Jin dynasty (317–420) to the present day.

I have chosen the Block Script for the practice sections throughout the book. It is the standard script for beginners because it teaches proper use of the brush. Written slowly, the Block Script allows the student to acquire fine control of his materials.

CHARACTERISTICS OF THE BLOCK SCRIPT
- The brush, in writing a single stroke, moves rhythmically in a movement described as *ton-sū-ton*, or "stop-move-stop."
- The feeling is organized and rigorous.

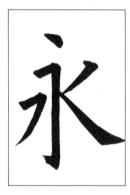

Semicursive Script (*Gyōsho*)
Three Kingdoms, A.D. 220–64

Though the Semicursive Script saw the light of day in the Three Kingdoms period, it was brought to perfection much later. In 316, coming under attack from northern tribes, many of the ruling nobility fled to the Jiangnan region south of the Chang Jiang river, establishing the Eastern Jin dynasty. In this picturesque and beautiful land, these people lived luxuriously and produced a magnificent culture. It was under these circumstances that the elegant, smooth, and simple Semicursive Script, which had appeared as a continuous form of the Block Script, was perfected by Wang Xizhi (307–65). Over many years, both the general and artistic uses of the Semicursive Script spread rapidly due to its fluidity, relative freedom of shape, and comprehensibility. Today, the Japanese generally employ a combination of Chinese characters in the Semicursive Script and *hiragana* (see below) for informal purposes.

CHARACTERISTICS OF THE SEMI-CURSIVE SCRIPT
- The entire character is written at one stroke with a fully loaded brush (i.e., there is no re-inking of the brush).
- The movement of the brush is rhythmical and fluid.
- The shape of the character is free and unrestrained.

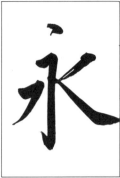

Types of Characters

PICTOGRAPHS

Chinese characters began as primitive pictographs of natural objects, including many sorts of birds and beasts, in addition to the human body, dwellings, and utensils.

IDEOGRAPHS

The Chinese character for the concept "above" was originally written as a point over a horizontal line: ⸜ . "Under" was represented as a point beneath a horizontal line: ⸝ .

While the early pictographs were concrete signs, the ideographs were symbols, showing relative position, number, or other relationships.

The combination of the concrete and the symbolic formed the matrix from which developed every other type of character. One way of forming new characters with distinctive semantic values was by combining two existing characters, as demonstrated below.

SEMANTIC COMBINATIONS

Of these new types of characters, one was formed by a juxtaposition of two semantic units that produced a third. The meaning of the new character was a synthesis of the first two. For example,

(明) *bright*. The combination of sun ☉ with moon ☽ indicates something very bright.

(林) *woods*. 朩 is a tree, and two trees symbolize many trees: in other words, a woods.

(見) *to see*. ⌀ is an eye and 𛰚 is a person, giving us someone with the ability to see.

SEMANTIC-PHONETIC COMBINATIONS

Another type of character combined a semantic unit with a phonetic unit. This character took its meaning from one, its prononciation from the other. For example,

星 (星) *star*. The Japanese phonetic reading, *sei*, is taken from 生 . The meaning derives from ⊙ , which represents bright things in the sky, like the sun.

姓 (姓) *surname*. The Japanese phonetic reading for this Chinese character is also *sei*, coming from 生 . The meaning derives from 女 , or "woman," in that family lineage at the time was matriarchal.

The Japanese Alphabet

Not too long after Chinese characters, with all their complexity, came into use in Japan sometime before the fifth century A.D., the Japanese began, in addition, to develop two phonetic systems of writing. One of these alphabets is called *katakana*, the other *hiragana*. *Katakana* symbols are simply one part of a Chinese character, sometimes stylized or simplified, but read phonetically. That is, they are more akin in function to the English alphabet than to Chinese characters. The table shows a few *katakana* and the Chinese characters from which they were extracted. Today, *katakana* symbols, with their spiky, abrupt forms, play a very small role in calligraphy, and therefore do not fall within the province of this book. On a practical level, however, *katakana* are quite useful in many ways, most often in writing words borrowed from English or other foreign languages.

Hiragana symbols are similar to *katakana* in that they are phonetic in nature, but they differ slightly in origin. Rather than being uprooted elements of Chinese characters, they are a radical simplification of whole characters. The history of *hiragana* has not always been smooth, however, with sometimes a number of different symbols, quite confusingly, representing a single sound. This messy, awkward state of affairs was rectified in 1900, when the government stepped in and reduced the number of *hiragana* symbols to one for each sound, giving us the system as we know it today. In fact, it was at this point that the term *hiragana* was coined. In their previous history, these symbols were known as *kana*, and still are today in calligraphy circles,

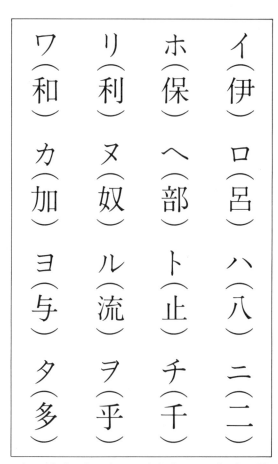

イ(伊) ロ(呂) ハ(八) ニ(二)
ホ(保) ヘ(部) ト(止) チ(千)
リ(利) ヌ(奴) ル(流) ヲ(乎)
ワ(和) カ(加) ヨ(与) タ(多)

Examples of the *katakana* alphabet, with the Chinese characters from which each was derived immediately below.

い(以) ろ(呂) は(波) に(仁)
ほ(保) へ(部) と(止) ち(知)
り(利) ぬ(奴) る(留) を(遠)
わ(和) か(加) よ(与) た(太)

Examples of the *hiragana* alphabet, with the Chinese characters on which they were based.

although in common parlance the term now refers indiscriminately to both *hiragana* and *katakana*. *Hiragana* is used mainly to record grammatical inflections in verbs, adjectives, and adverbs, so that a Japanese text is a mixture of Chinese characters, *hiragana*, and, occasionally, *katakana*.

For our purposes, the big difference between *katakana* and *hiragana* is that the latter is well favored by calligraphers. Its well-rounded and sweeping lines are highly congenial to their art. It is for this reason that I have devoted a later section to the writing of *hiragana*.

和紙の手ざわりそ行ていんでよう
越前、雪の国、その雪どけの水が強く美し
く紙の繊維をさらすのだと私に教えて

An example of *hiragana* and Chinese characters as they appear in a letter.

Brushes, Paper, and Other Materials

The novice calligrapher will be in need of certain materials and equipment before he or she can commence. Although these can be relatively inexpensive objects and all are easily found in Japan, this might not be the case in other countries (see list of shops at the end of the book). A certain amount of invention and ingenuity may be called for, together with some experimentation, to obtain the desired effects. At the same time, however, I would like to stress that the proper paper, brushes, and ink all have certain unique properties that may be difficult to simulate using lesser materials. Some effort to obtain the correct tools will be amply rewarded in the finished work.

Ink *(Sumi)*

The ink most often used in calligraphy comes in a solidified form as blocks or sticks. It is made of soot obtained by burning certain kinds of wood and held together with a binding agent. Ink is available in a bewildering variety of qualities and hues, appealing to a wide range of individual tastes and levels of skill. The cost of a stick of ink also varies, but for the beginner an inexpensive variety will be quite sufficient.

Nowadays it is possible to buy bottles of premade liquid ink. Although the quality and color do not necessarily please a discriminating eye, it ensures uniformity and consistency of performance.

While the ease and convenience of liquid ink can be counted as merits, they are also drawbacks to savoring the art of calligraphy to the full. Granted, if writing as many characters as possible in a short time were the objective, then liquid ink would certainly be a valuable timesaver. But this is not the case. Prolificacy alone is not the goal of any serious student. The slow, delicately laborious task of rubbing the ink on the stone, precisely because it is slow, becomes a central and necessary part of the preparation of the mind without which writing of any depth cannot be achieved. Consequently, the ink stick is highly recommended.

Ink Stones *(Suzuri)*

There are many types of ink stones. Some are carved and some ornamented; others are quite plain. In essence, any vessel that will hold liquid will do as an ink receptacle. In order to rub the ink, though, a proper ink stone that has a well for water and a flat surface for rubbing is necessary. After use, the stone should be thoroughly washed to keep the ink from building up on the surface and affecting the quality of future preparations.

Ink sticks.

Ink stones.

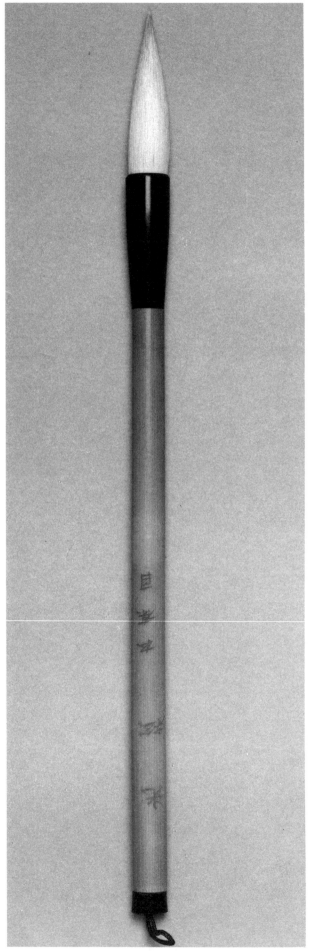

The most commonly used type of brush (life-size).

Brush (*Fude*)

Brushes come in many sizes and qualities, ranging from giants taller than the person who wields them to tiny, fragile ones with delicate reedlike stems. Normally the body of the brush is made of bamboo, the bristles of the hair or fur of some animal. An ordinary brush, of the type that can be purchased quite easily and inexpensively from a Chinese handicraft store or most art supply shops, will be sufficient.

To protect the brush, the bristles will have been coated with a special waterproof paste. This paste must be washed away, and the bristles thus softened, for approximately two-thirds of the bristles' length from the tip down. The remaining one third should be left relatively untouched and stiff, for in the beginning not everyone can wield a fully flexible brush.

Various types of brushes (leftmost example identical to life-size brush).

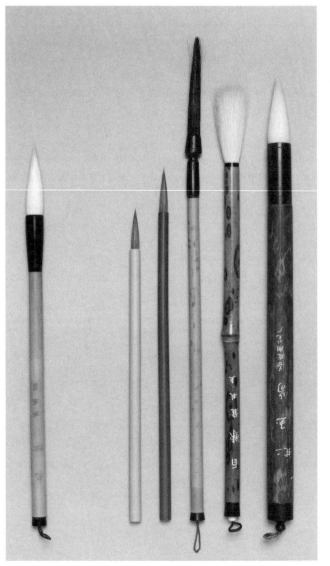

After each session of writing, the bristles must be carefully washed to remove any excess ink that has accumulated near the base. The object of washing is simply that—not to restore the brush to its original pristine state. Overzealous washing will erode the soft but flexible strength of the bristles. The brush is then dried by making a number of strokes on a sheet of used practice paper to remove the excess water and to straighten the bristles.

Brush Mat (*Fudemaki*)

Between practice sessions the brush should be stored so that the bristles do not become damaged or bent out of shape. Ordinarily, you can simply put it in a box for safekeeping. For occasions when you must go out (say, to your teacher's home for a lesson), however, there is a special mat made of bamboo slats which is called a *fudemaki*, or brush wrapper. You simply place the brush on the mat, wrap it up, and tie the mat securely. Bound snugly in the *fudemaki*, the brush can be taken along without the slightest fear of its coming to harm.

Calligraphy Paper (*Shodō Yōshi*)

Japanese or Chinese calligraphy paper produces the best results. If this is not to be had, use paper that absorbs but does not bleed or ooze to excess. Even newspaper will do in a pinch.

Though other kinds of paper may be used, my advice is to start with some medium to fine quality Japanese calligraphic paper. That way, you will learn from the very beginning to appreciate the subtle interplay of ink and paper. Standard practice paper (*hanshi*) is 24 cm. by 33 cm. Calligraphic paper is rough on one side, smooth on the other. The smooth side is the face of the paper, the side generally used for writing.

Paperweight (*Bunchin*)

Anything will do, from a heavy flat polished stone to a Western or Oriental paperweight. The shape and material should be aesthetically pleasing and hold the paper firmly in place while one is writing, but it should not hinder the movement of hand or brush. Nor should it mark the paper.

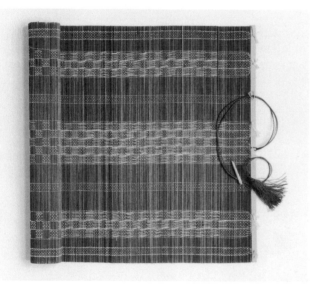

Brush mat.

Paperweights.

Mat (*Shitajiki*)

Once again, almost anything can serve as a mat. The mat functions as a cushion for the paper and protects it from any minor irregularities of the work surface. It also protects the work area, absorbing excess ink that bleeds through the paper. An oblong piece of heavy wool or thick felt, if sufficiently firm, is ideal.

Preparing to Write

When selecting a place and time for practice, there are several things to keep in mind. Calligraphy takes time, so choose an hour when you know there will be few or no interruptions. A few moments sandwiched in between other projects will not do for the aspiring calligrapher.

A quiet and uncluttered room is conducive to good work. And a low table is recommended, though not absolutely necessary. A temporary table can be fashioned from two piles of books and a board. But make sure it is stable. The tabletop should be about the same level as your navel when sitting on your knees, legs tucked under, toes pointed to the rear. If you prefer a regular table and chair, take care that your posture does not deteriorate.

Before sitting down to practice, gather and arrange all your writing equipment, as shown in the picture.

As you approach the table to begin writing, set aside the cares of the day and leave your mind free to enjoy the task ahead. Rest the edge of your left palm on the paper, straighten your back, and lean slightly forward, your stomach lightly touching the edge of the table. In the Orient, the mind is traditionally said to reside in the *hara*, or belly, not in the head, as in the West. You will find that sitting in the Japanese style, while uncomfortable at first, is an excellent posture for composing yourself, and it is the recommended one for writing.

Now that you are sitting properly, you are ready

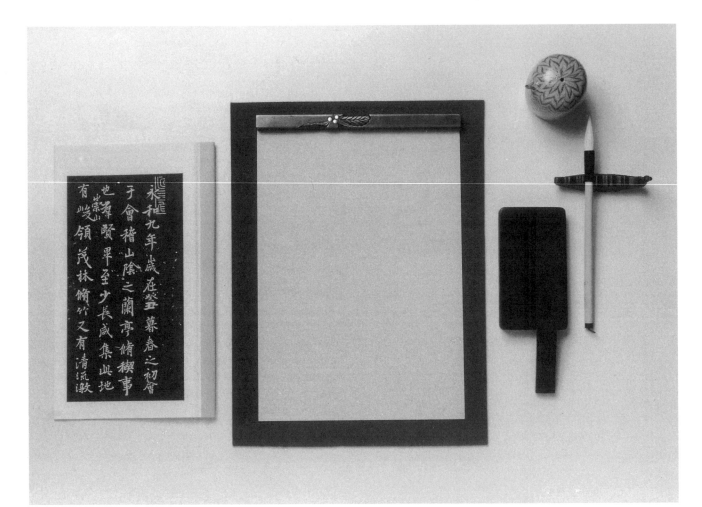

Equipment properly arranged: from left, calligraphy model, paperweight, paper, mat, ink stone and ink stick, water holder, brush rest, and brush.

to make the ink. First, pour about one tablespoon of water into the ink stone. Dip the ink stick into the well and draw some of the water onto the flat surface. Move the ink stick back and forth with leisurely, even strokes. Don't press too hard, as this will adversely affect the quality of the ink. Keep the ink stick more or less perpendicular to the surface of the stone as you rub. As the ink on the surface turns black, pull more water from the well until all of the water there has turned black. Be sure to mix thoroughly the ink in the well with the ink on the rubbing surface. This process will take about twenty minutes or so. Check the quality of the ink by drawing a line on your paper. Continue to rub until the ink is of a suitable thickness. During one practice session you may need to make ink several times.

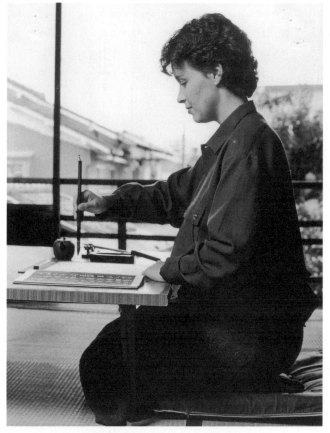

Sitting in Japanese style before a low table.

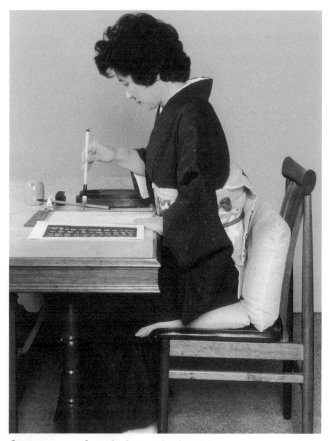

Sitting on a chair before a high table.

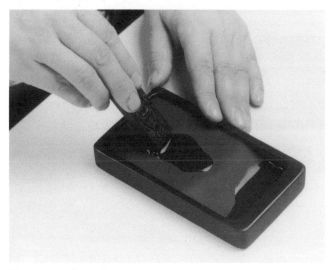

Preparing the ink.

Lines drawn to test the quality of the ink. The line at top ▶ is too thin, calling for more rubbing of the ink stick.

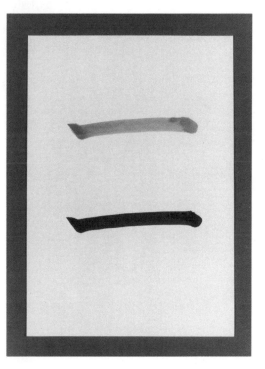

17

Handling the Brush

The brush should be grasped lightly but firmly, with the middle and index fingers in opposition to the thumb. This grip is similar to that with which we commonly hold a pen. There is a difference, however, in the angle at which the brush is held. As a rule, it should be held perpendicular to the paper. A brush has no front or back, and may be moved easily in any direction, but only if held perpendicular to the paper.

The brush is moved not from the wrist alone, but in harmony with the movements of the whole arm articulated at the shoulder. To ensure that this movement remains fluid and easy, the elbow, held almost horizontally, should feel almost buoyed up, as if it were floating in water at a constant level. Although this may feel a little awkward in the beginning, with a little perseverance it will soon come to feel quite natural.

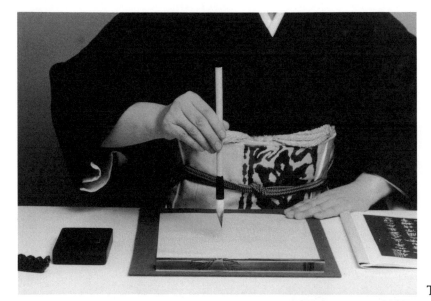

The proper way to hold the brush.

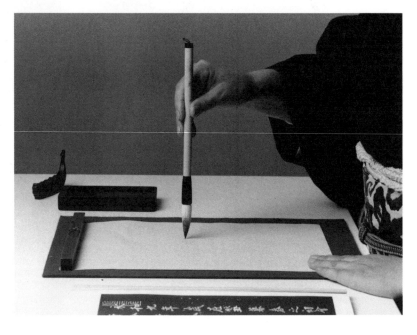

PART II

The grid overlay on the following pages is intended solely as an aid to proper calligraphic placement and balance. It does not appear on standard practice paper. If you wish, however, draw a grid on somewhat thickish paper and place it under the practice paper so that the lines show through and act as a guide to your writing.

The Basic Strokes

In writing any character, the order of the strokes (which is written first, which second, etc.) is fixed and must be learned by heart. We will begin, however, by learning the basic strokes that appear in all characters, and then how to combine them in specific characters in their proper order.

For the first exercise I have chosen the two most basic strokes: the horizontal line and the vertical line. After practicing these two strokes, we will go on to the character *ei*. Traditionally, this character has been selected as a model for beginners because it contains all the basic strokes which, varied slightly, appear in the composition of all characters.

Cardinal Points of Good Practice

1. Relax. Stiff shoulders and arms produces stiff characters.
2. Remember that the wrist is not so much a joint that moves by itself as a part of the whole arm. Any movement of the brush's tip should be accompanied by a corresponding movement of the elbow, which must appear to float. This floating movement is then transmitted down to the flexible bristles of the brush.

3. Write each and every character resolutely in the center of the page.
4. Be conscious of the delicate and shifting balance between black and white. Calligraphy is not merely a manual skill. The eye must be trained just as in the other representational arts.
5. Calligraphy requires a great deal of practice, and it may take some time before you are able to approximate the models set before you. Frustration can best be avoided by suspending judgment on your efforts.

The Horizontal Line

This stroke is by no means as simple as it may appear. The more rigorous and traditionally minded schools of calligraphy would have the beginning student practice nothing other than this single stroke for months before moving on to the practice of others. There is, indeed, a whole world to be discovered within this seemingly simple line.

In both Chinese and Japanese this stroke means "one" (read *ichi* in Japanese) and signifies a base or foundation, the origin or point from which something takes its beginnings.

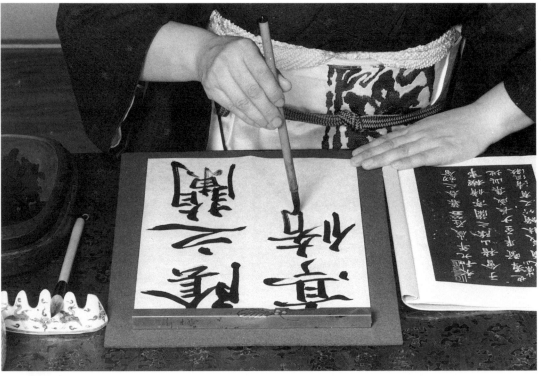

The author writing calligraphy.

How to Write the Horizontal Line

1. This stroke is written from left to right.
2. Angle: There is a slight upward tilt in the stroke.
3. The brush, as it comes into contact with the paper, moves obliquely downward at approximately 45° (see drawing). Then, the brush stops briefly and there is a rebound off to the right.
4. When the brush reaches the end of the stroke, the tip is moved back, slightly retracing its path. The brush is then lifted smoothly away from the paper, somewhat to the left of the end of the line, giving a smooth appearance to the conclusion of the stroke. If one forgets to retrace, the sudden lifting of the brush from the paper often results in a smudged ending.
5. The rhythm of the stroke is of utmost importance since the final shape is a result of this rhythm. The Japanese describe it as *ton-sū-ton*, which may be translated as "stop-move-stop."

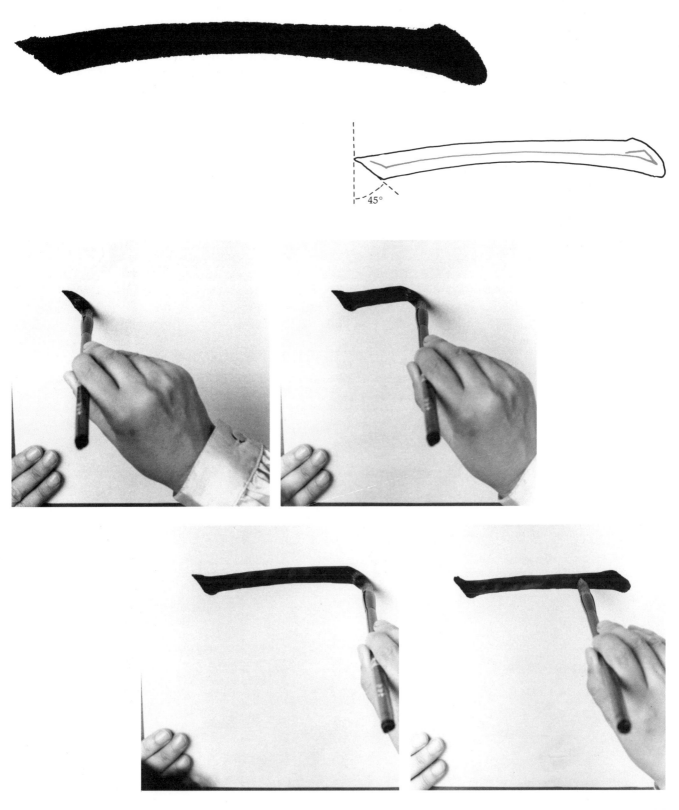

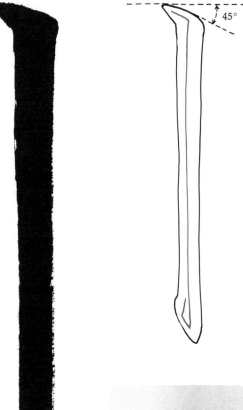

The Vertical Line

Saying nothing more about the mandatory length of apprenticeship required to master the horizontal line, let us pass directly on to the complementary second stroke of the calligrapher's canon: the vertical line.

How to Write the Vertical Line

1. This stroke is written from top to bottom.

2. Angle: straight down.

3. When the brush makes contact with the paper at an angle of approximately 45°, it moves from the upper left to the right at a slant of approximately 45°, stops, or rather pauses, and then continues straight down the page.

4. At the end of the stroke, the brush stops and the tip is taken back up the line, retracing a little way the downstroke to ensure a neat finish.

5. The rhythm is the same as for the horizontal stroke: stop-move-stop.

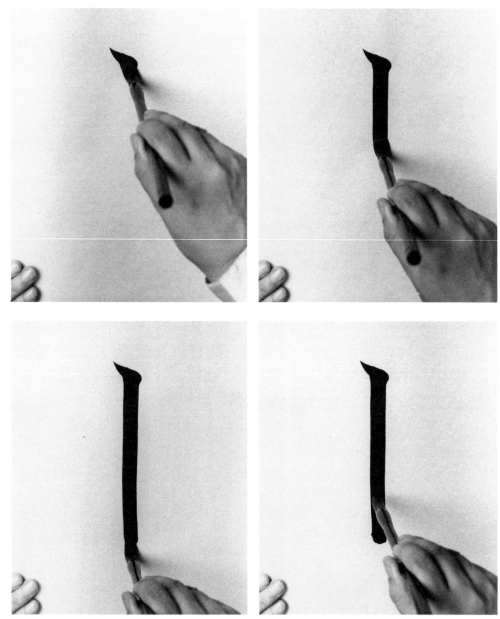

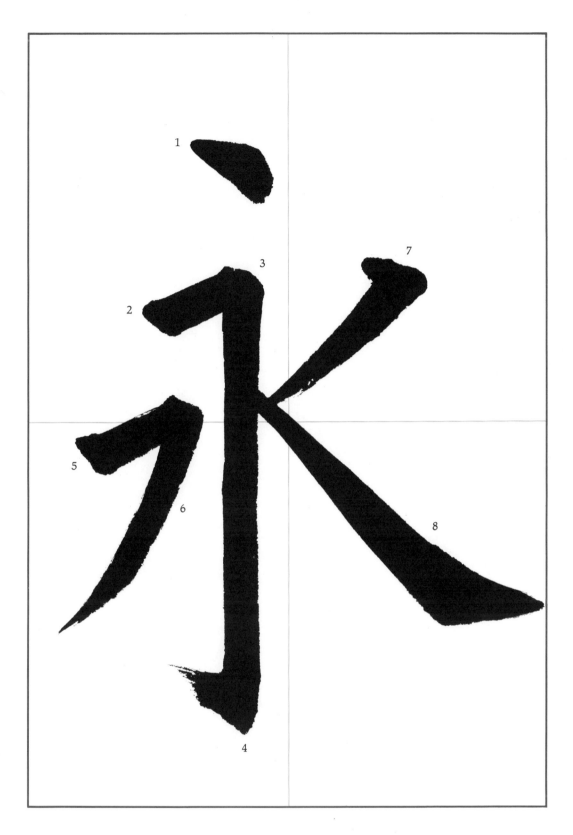

The Eight Basic Techniques of *Ei*

Once these two elementary strokes have been practiced and understood, it is time to move on to something more complex. There is a standard character in Japan that the beginner must cut his teeth on, the aforementioned *ei*, meaning "long time," "eternal," or "forever."

As I pointed out earlier, this single character is invaluable to the student, as it contains the elementary techniques that appear in all characters, from the simplest to the most complex. This single character,

then, serves as an immensely practical standard to which frequent returns should be made, or which may even serve as a warm-up exercise before tackling something new.

Before attempting to write the entire character, however, spend some time practicing the individual strokes. Rather than perfection, aim at familiarity with each stroke before starting to practice the character as a whole. Remember that brush writing is as much a matter of mind and spirit as technique.

The Dot

This is exactly the same as the first part of the vertical stroke previously practiced. The brush is lowered at an angle of approximately 45° onto the paper, then moved downward, brought to a halt, and removed after being returned to the center of the dot.

For the horizontal and vertical lines (#2 & 3), see pages 20–22.

The Tail

This important shape results from the brush's rebounding upward. The triangular spike is made by lifting the brush off the paper as it moves up the page, so that finally, at the end of the stroke, only the very tip of the bristles are in contact with the paper.

The Sword Blade

Here the brush moves upward at an angle from left to right, comes to a stop, veers up the page to the right, and gradually lifts off the paper to produce a sharp tail.

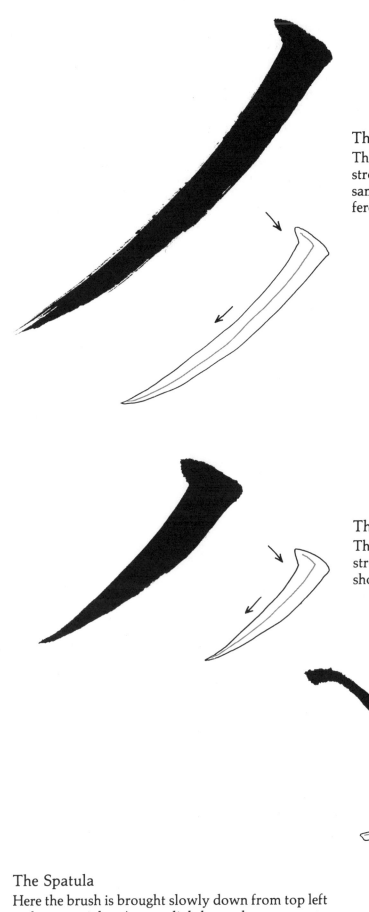

The Inverse Sword Blade
This stroke begins in the same way as the previous stroke, but moves downward to the left, giving the same long sword-blade effect as before, but at a different angle.

The Dragon's Claw
This is simply a shortened version of the previous stroke, the same movements being executed in a shorter time and space.

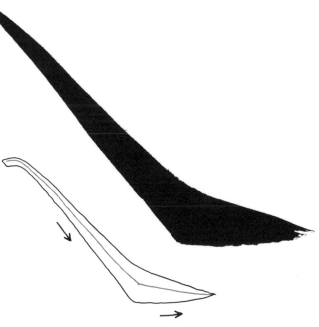

The Spatula
Here the brush is brought slowly down from top left to bottom right. As you lightly apply pressure to the brush, more of the bristles come into contact with the paper and the stroke thickens. After a pause, the brush is lifted slowly from the paper while moving away and slightly upward and to the right.

Writing *Ei*

Anyone dealing with these eight techniques, beginner or otherwise, is dealing with the core of the calligrapher's art. Simple as they are, even a little experience shows their complexities, the difficulty in learning to write them well. And "well" means regularly and consistently well. The range of possible variants becomes clear as soon as the brush touches the paper, from the moment one is forced to control the brush's movements to produce the desired effect. Whatever happens, do not become frustrated or discouraged by initial difficulties: There is nothing intrinsically difficult in the eight strokes themselves, and they will soon bend more easily to your will as you learn to handle the brush.

Your progress depends a good deal on eliminating interference in the form of frustration, annoyance, and distraction. The lines themselves are the very essence of simplicity. What is difficult is the attention and concentration required to practice them.

When you begin to feel fairly comfortable with your brush and other equipment, and have gained familiarity with the eight basic techniques (five strokes), begin to practice the character *ei* in its entirety. When practicing this character, and others as well, you will find, at least in the beginning, that using a single sheet of paper for each character, and boldly centering that character, will bring better results than squeezing in several small characters on one sheet.

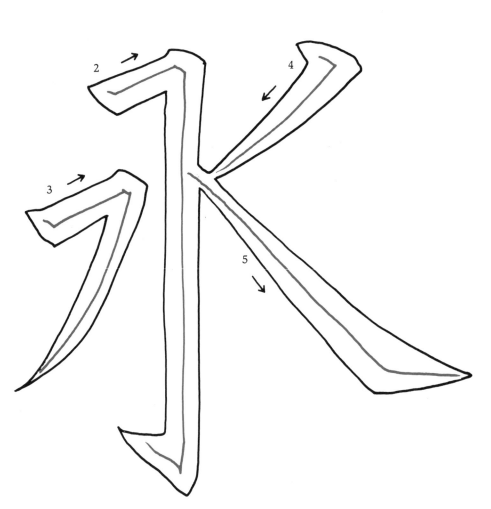

THE FIVE STROKES FOR *EI* IN PROPER ORDER
1: Dot.
2: Horizontal and vertical legs.
3: Sword blade and inverse sword blade.
4: Dragon's claw.
5: Spatula.

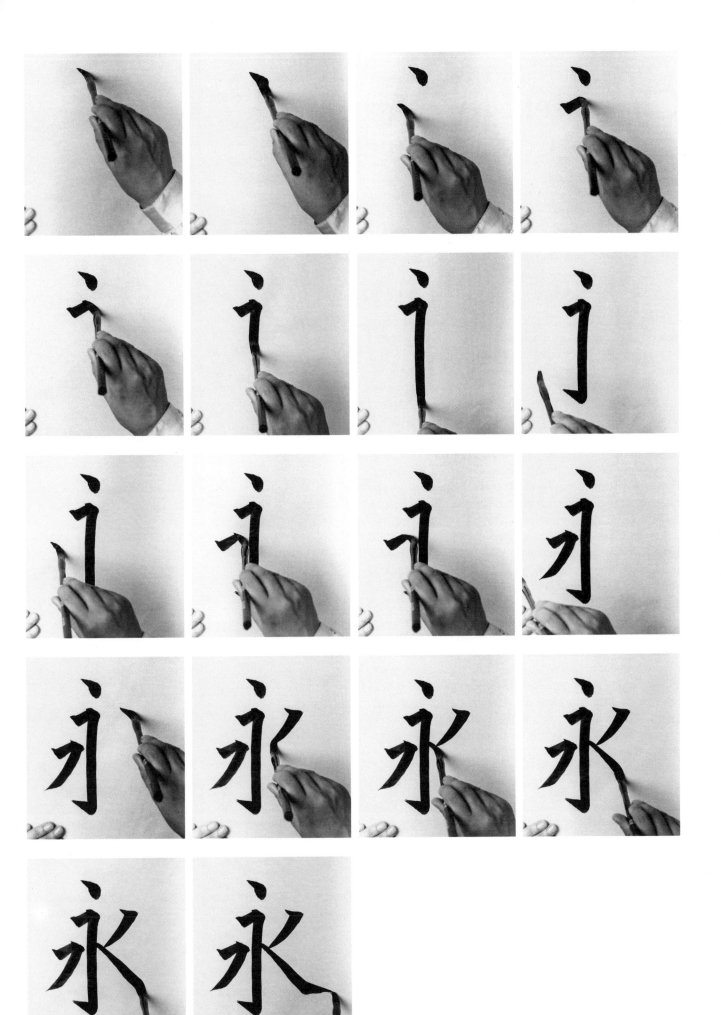

Characters to Learn:
The Five Colored Clouds

In this section we will take up five individual characters that make up a Chinese poem. The poem I have chosen is actually only one part of a longer work, although in Japan it often stands alone.

Literally, the five characters (which in Japanese are read *Tōten goshiki [no] kumo*) may be translated thus: "The five colored clouds in the eastern sky."

To the Chinese the most essential colors are blue, red, white, black, and yellow. These five colors in turn symbolize all colors. East symbolizes spring, the season of birth and growth. Therefore, the beautiful and colorful clouds which float in the eastern sky suggest a joyful, happy, bright future.

Let us first practice each of the five characters singly. Then, on your own, after having attained a degree of confidence in your ability to reproduce the individual characters, try writing the poem in its entirety on one sheet of paper—centered, from top to bottom. The space at the top of the paper and that at the bottom should be about the same, as should that between the characters. Writing all five on one sheet of paper means that the size of each character must be considerably reduced. And it will take some practice to achieve a proper overall balance. Remember as you write that the proportioning of white and black is as important as the characters themselves.

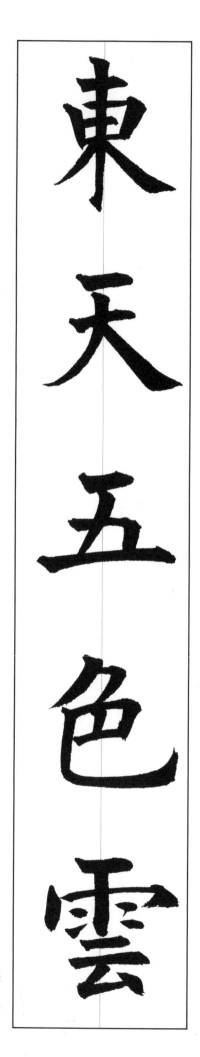

"The Five Colored Clouds" written on narrow paper, an improvement on standard practice paper for this type of calligraphic arrangement. If such paper cannot be found, it can easily be made with the judicious use of a pair of scissors.

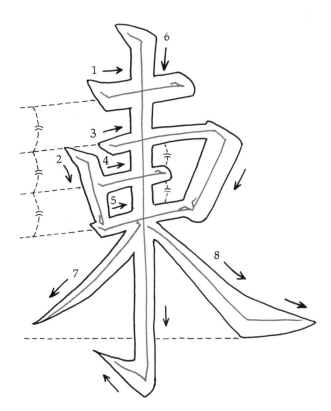

Reading: *tō*
Meaning: east

1: Horizontal line. Note that all of the horizontal lines are thinner than the vertical lines.

2: The vertical line is written from the top downward and slants inward.

3: Horizontal leg and vertical leg. Come to a full stop at the end of the horizontal leg; then write the vertical leg with an inward slant. Change the direction of the brush without losing contact with the paper.

4 & 5: Horizontal lines. Slant all horizontal lines equally and leave about the same amount of space between them.

6: Vertical line and tail.

7: Inverse sword blade.

8: Spatula. Don't rush this final stroke.

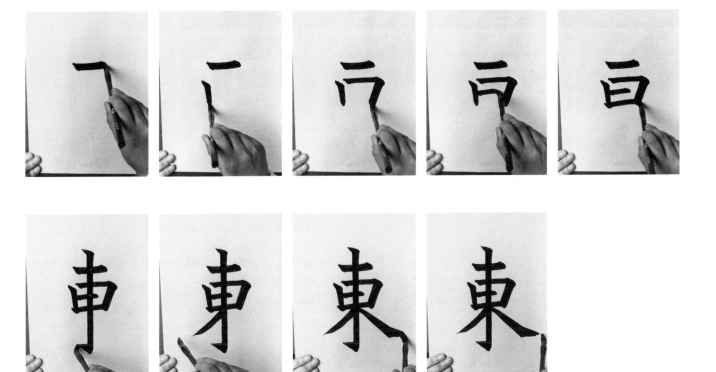

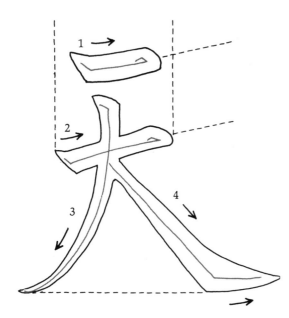

Reading: *ten*
Meaning: heaven

1 & 2: Horizontal lines. Of not quite the same length, these two lines both incline slightly upward.

3: Inverse sword blade. This line and the spatula should be written at the same angle.

4: Spatula. For this important stroke, move the brush slowly and carefully.

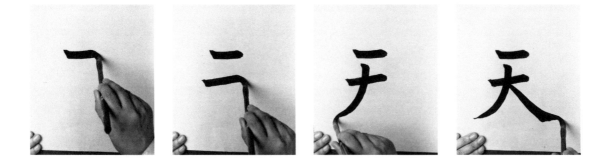

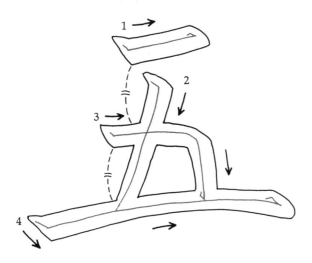

Reading: *go*
Meaning: five

1: Horizontal line. The white spaces between the three horizontal lines should be about equal.

2: Vertical line slants outward.

3: Horizontal leg and vertical leg. Come to a full stop at the end of the horizontal leg and then write the vertical leg.

4: Horizontal line.

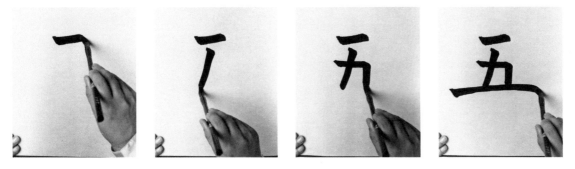

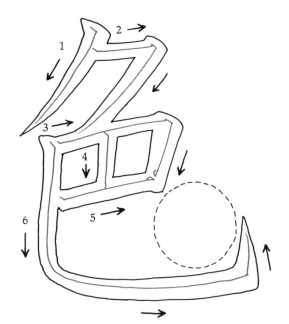

Reading: *shiki*
Meaning: color

1: Dragon's claw.

2: Horizontal line and dragon's claw. Come to a full stop at the end of the horizontal line; then, keeping the brush in contact with the paper, write the dragon's claw.

3: Horizontal leg and vertical leg.

4: Vertical line.

5: Horizontal line.

6: Vertical line and tail. The curve of the vertical line should show strength. Move the brush slowly here. At the end of the stroke, let the brush spring up sharply from the paper.

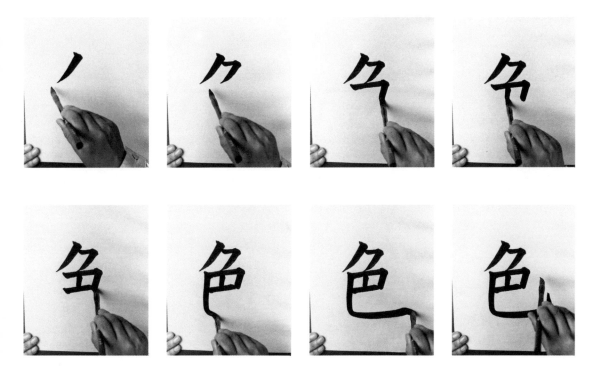

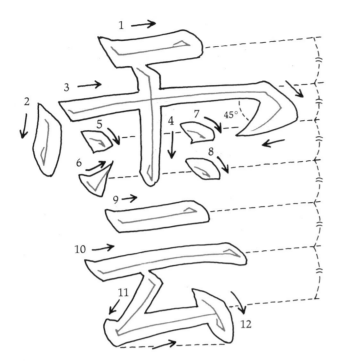

Reading: *kumo*
Meaning: cloud

1: Horizontal line.

2: Dot. This dot is slightly longer than usual.

3: Horizontal line and dragon's claw. Come to a full stop at the end of the horizontal line and do the claw at an angle of 45°.

4: Vertical line. This stroke should divide the horizontal line into one third (left) and two thirds (right).

5–8: Dots. Spring from dot 6 to write dot 7.

9–10: Horizontal lines.

11: Dragon's claw and horizontal line. Come to a full stop at the corner.

12: Dot. End this final stroke abruptly and boldly for good balance.

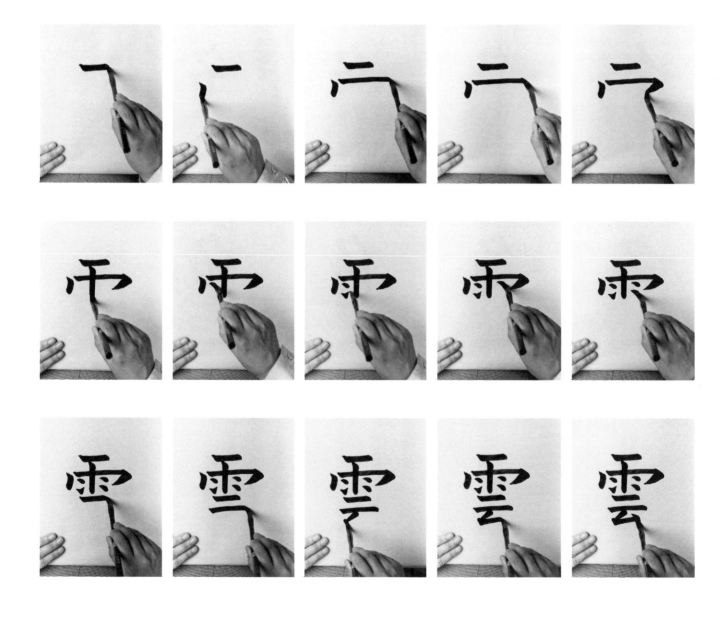

More Characters to Learn:
Once Started, Follow Through!

After having honed your skills on the preceding models, you may wish to try some of the characters in this section, choosing here and there as your fancy strikes you. I have abbreviated the instructions considerably, relying on your being familiar with most of the strokes. Incidentally, under the heading "Readings," you will notice that some words are in small capital letters, others in italics. Capitals indicate readings that have been inherited from China (but so pronounced by Japanese that no

Chinese is likely to recognize them), while the italic type is for native Japanese readings.

At this point, if you are still intrigued by the elusive power of these simple lines, slashes, and dots, I encourage you to seek out a calligraphy teacher to further refine your technique. With the proper guidance, your understanding of the fascinating art of calligraphy will grow deeper and deeper, and the future will reveal hour upon hour of satisfying and fulfilling artistic creation.

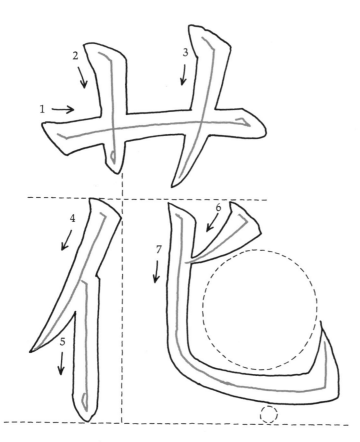

花 POINTS TO NOTE

3 & 5: Inverse sword blades.

6: Dragon's claw.

7: See the last stroke of 色 (p. 31).

Readings: KA, *hana*.

Meanings: flower, blossom, bloom.

In a broader sense, this character signifies the beauty of woman and of art and the brightness of life.

花 written in Cursive Script.

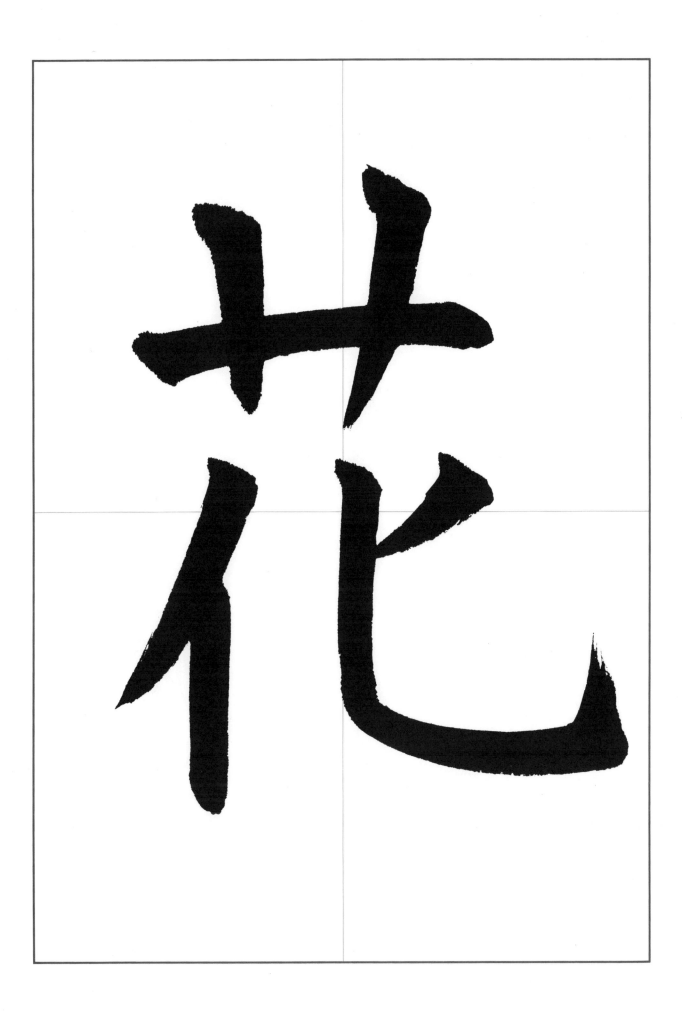

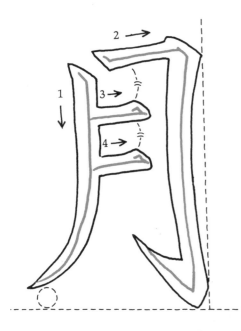

月 **Readings:** GETSU, GATSU, *tsuki*.
Meanings: moon, month.

光 **Readings:** KŌ, *hikari*.
Meanings: light, beam, radiance.

Together these two characters form the word *gekkō*, "moonlight."

月 POINTS TO NOTE

1: Vertical line and inverse sword blade.
2: Horizontal leg, vertical leg, and tail. At each corner, stop the brush completely. The vertical leg should be slightly curved for good balance.

Spaces between horizontal lines are almost equal.

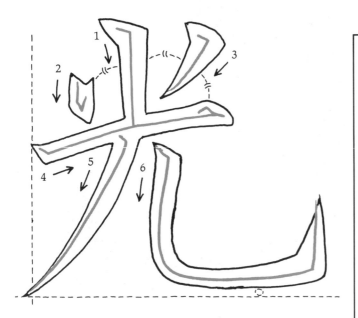

光 POINTS TO NOTE

2: Stop and rebound, moving on immediately to the next stroke.
3: Dragon's claw.
5: Inverse sword blade.
6: See the last stroke of 色 (p. 31).

Spaces between strokes 1 and 2, 1 and 3, and 3 and 4 are equal.

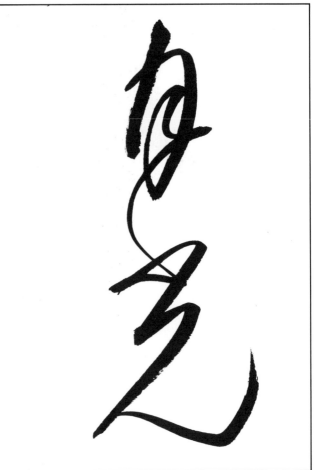

月光 written in Cursive Script.

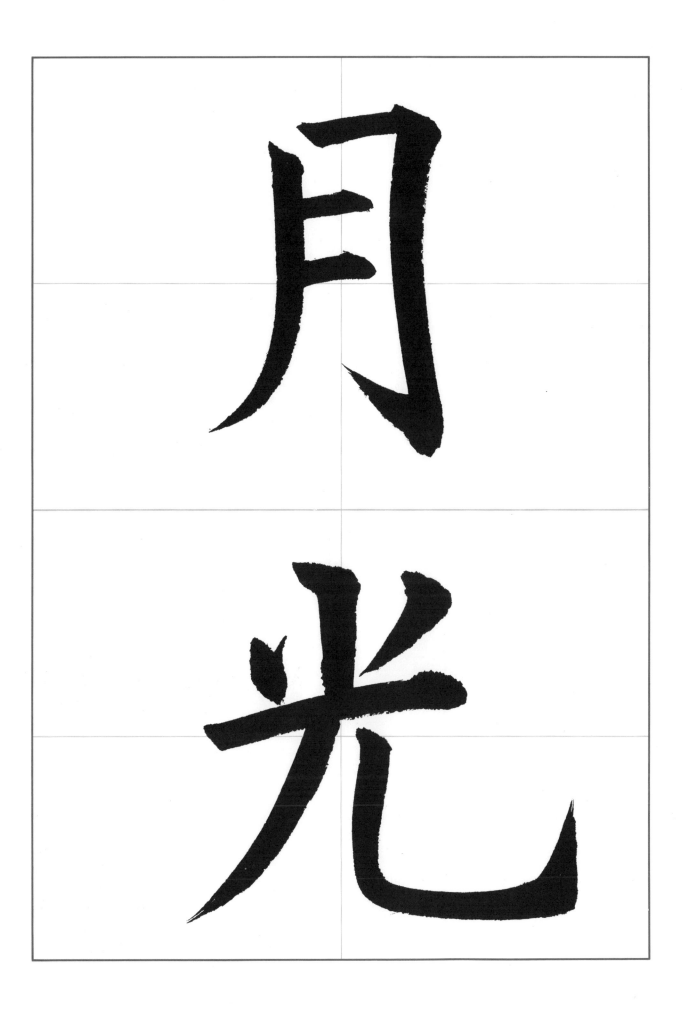

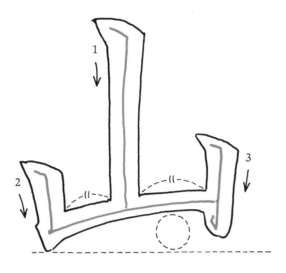

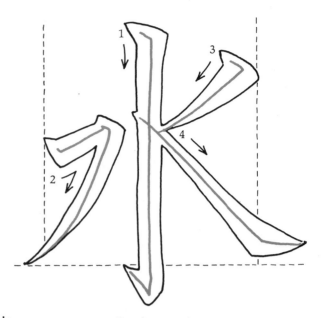

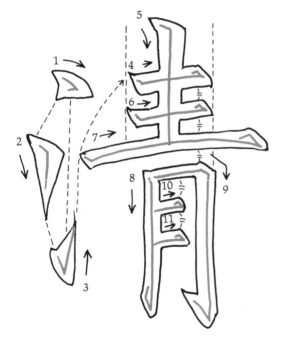

山 POINTS TO NOTE

1: Have the vertical leg join the horizontal baseline at the center.

2: Short vertical line and horizontal baseline. After the vertical line, stop the brush completely, taking care not to let it leave the paper, and then write the horizontal line.

水 POINTS TO NOTE (See 永, p. 26.)

山 **Readings:** SAN, *yama*.
Meanings: mountain, hill.

水 **Readings:** SUI, *mizu*.
Meanings: water, fluid.

清 **Readings:** SEI, *kiyoi*.
Meanings: clean, clear, pure.

Combined in the phrase *san sui kiyoshi*, the meaning is "[Both] mountains and rivers are [very] clean," evoking the image of a peaceful and prosperous rural district.

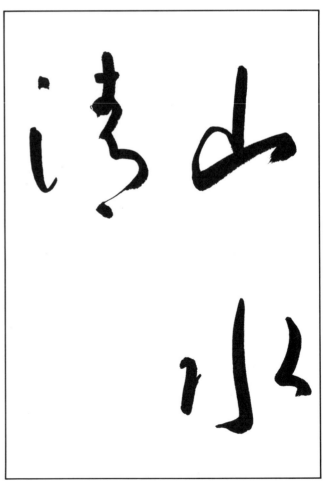

清 POINTS TO NOTE

1 & 2: Dots. Continue directly from stroke 2 to stroke 3.

3: Let the bristles meet the paper obliquely and then head up for stroke 4.

Horizontal lines are slightly thinner than vertical lines. Spacing between horizontal lines are equal.

山水清 written in Cursive Script.

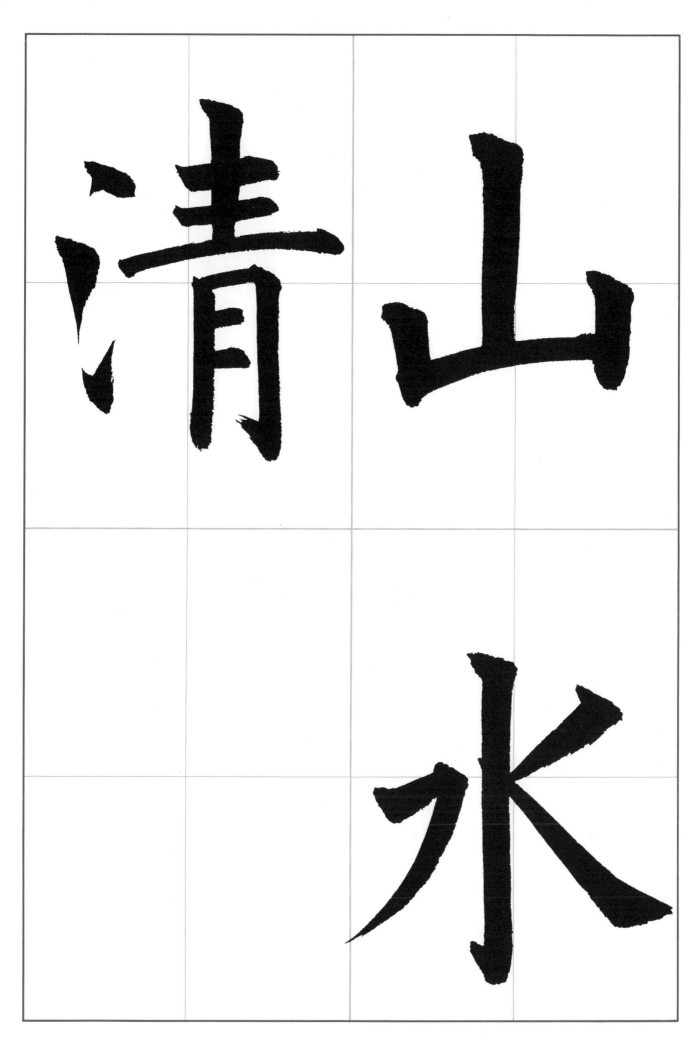

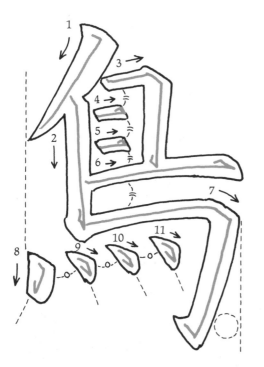

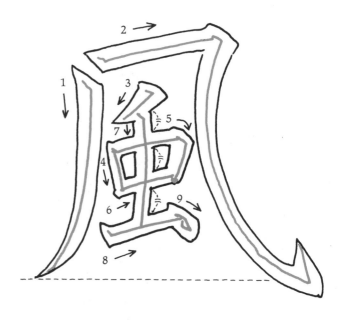

鳥 POINTS TO NOTE

1: Dragon's claw.

3 & 7: Horizontal and vertical legs. At the end of the horizontal leg, stop the brush completely and write the vertical leg from the top downward. In stroke 7, slant the leg inward. Stop at the end and head up, creating a tail.

8: Dot. Write obliquely to the left.

9–11: Slant to the right.

花 POINTS TO NOTE (See p. 34.)

月 POINTS TO NOTE (See p. 36.)

鳥 Readings: CHŌ, *tori*.
Meanings: bird.

風 Readings: FŪ, *kaze*.

Meanings: wind, manners, fashion, style.

The four natural phenomena expressed in the phrase *kachōfūgetsu* are meant to represent and symbolize the beauty of all things in nature.

風 POINTS TO NOTE

1: Vertical line and sword blade.

2: Write horizontal leg, stop, then move downward in an arc, applying same technique as in the last stroke of 色 (p. 31).

9: Dot.

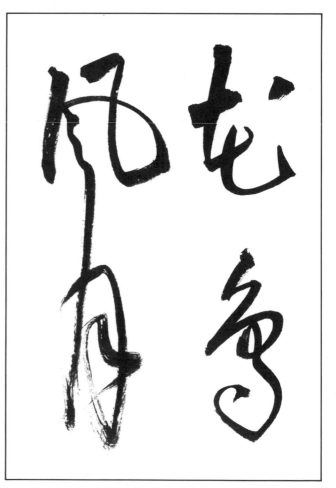

花鳥風月 written in Cursive Script.

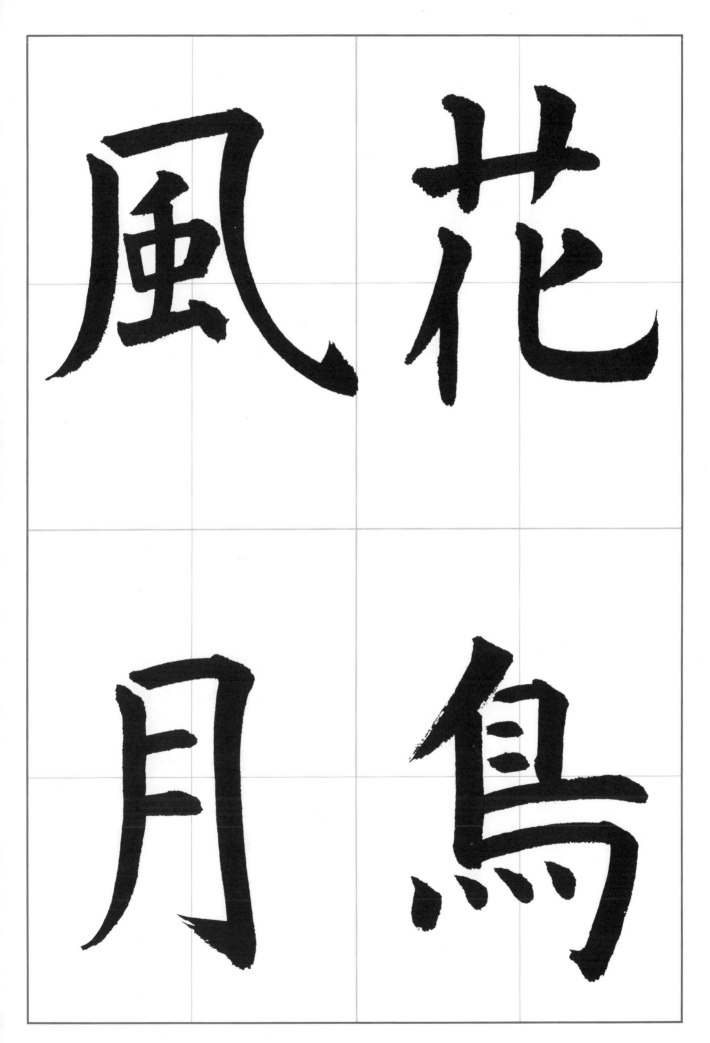

風花

月鳥

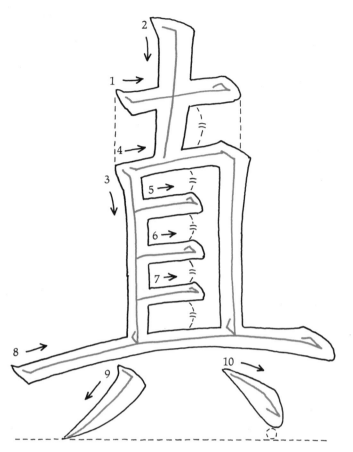

真 POINTS TO NOTE

4: Horizontal leg and vertical leg. Stop completely at the end of the horizontal leg, then move the brush downward.

9: Dragon's claw.

10: Dot. Write this boldly but carefully.

Horizontal lines are thinner than vertical ones, and horizontal spacing is almost equal.

Readings: SHIN, *makoto*.
Meanings: truth, genuineness.

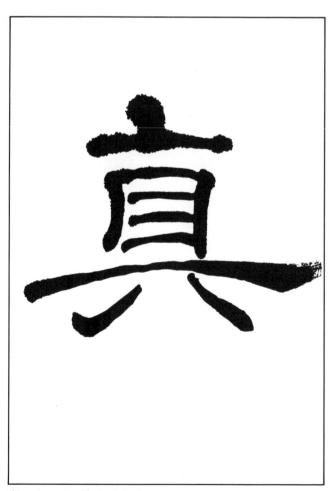

真 written in Clerical Script.

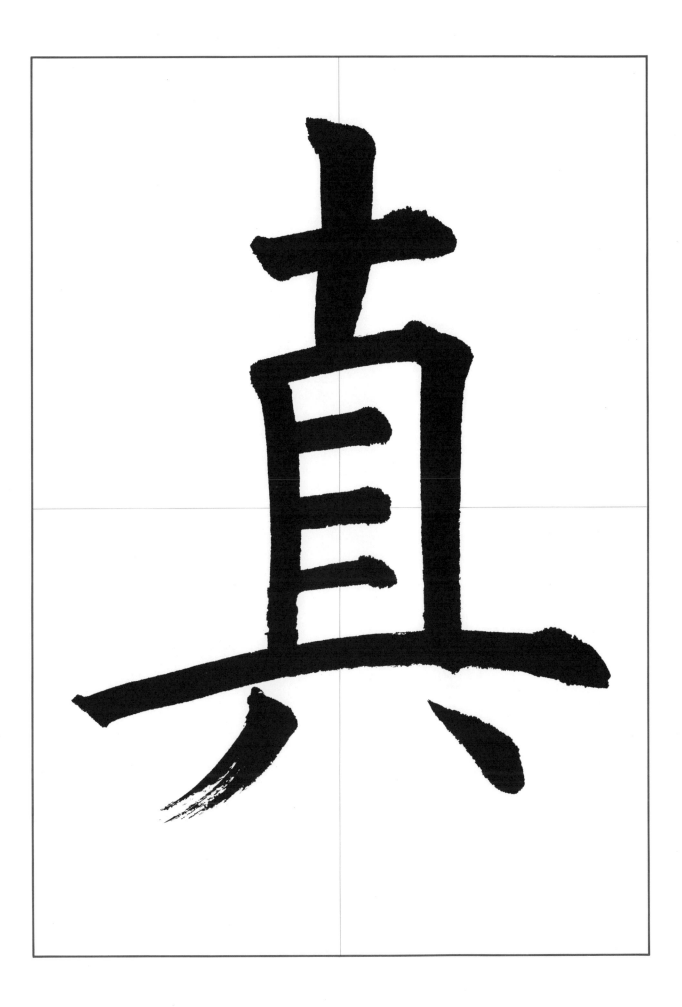

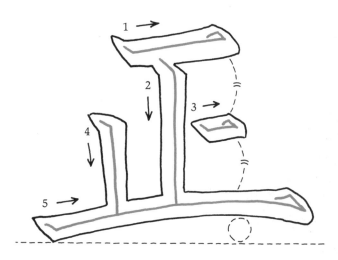

正 POINTS TO NOTE

2: This stroke joins line 5 at midpoint.

Horizontal spaces are nearly equal.

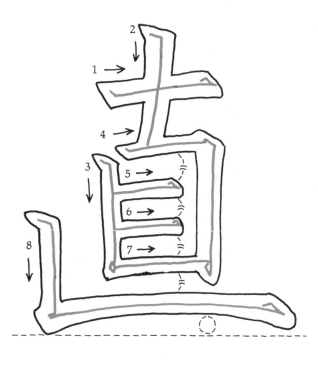

正 **Readings:** SHŌ, *tadashii*.
Meanings: right, truthful, correct.

直 **Readings:** JIKI, CHOKU, *naosu*.
Meanings: correctness, straight, repair, correct.

These characters form the word *shōjiki*, "honesty," "frankness."

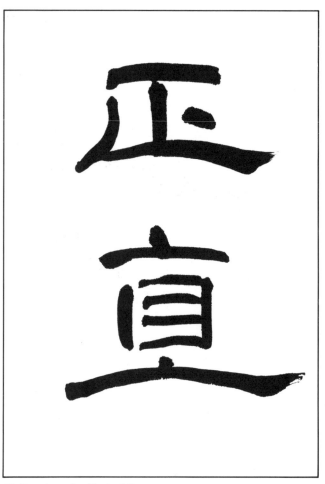

直 POINTS TO NOTE

4: Horizontal leg and vertical leg.

8: Vertical leg and horizontal leg.

In both strokes (4 & 8), stop the brush completely at the corner and change direction, keeping the brush in contact with the paper. The last stroke should be done boldly to provide overall balance.

Horizontal spaces are almost equal.

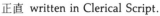

正直 written in Clerical Script.

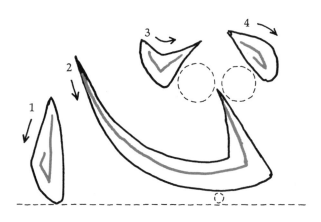

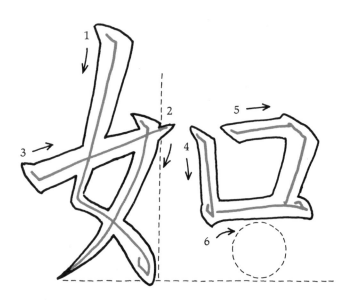

心 POINTS TO NOTE

1: Dot variation.

2: Thicken the line gradually as you write. Make a complete stop at the end and head up strongly.

3: Apply the brush obliquely to the paper, stop, and then bound for 4.

4: Dot.

水 POINTS TO NOTE (See 永, p. 26.)

心 **Readings:** SHIN, *kokoro*.

Meanings: heart, mind, thought, feeling.

如 **Meanings:** JO, *gotoshi*.

Meanings: such as, as if, like.

The meaning of *kokoro mizu [no] gotoshi* is "a heart like water," that is, pure and translucent.

如 POINTS TO NOTE

1: Upper part of the line is an inverse sword blade.

2: Inverse sword blade.

3: Horizontal line. At the end, lift the brush lightly from the paper and then, without coming to a stop, move it into position for 4.

5: Horizontal and vertical legs. Stop completely at the corner.

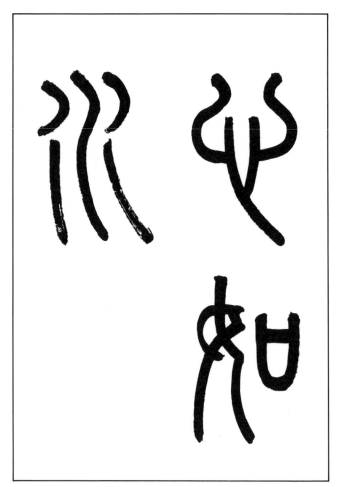

心如水 written in Seal Script.

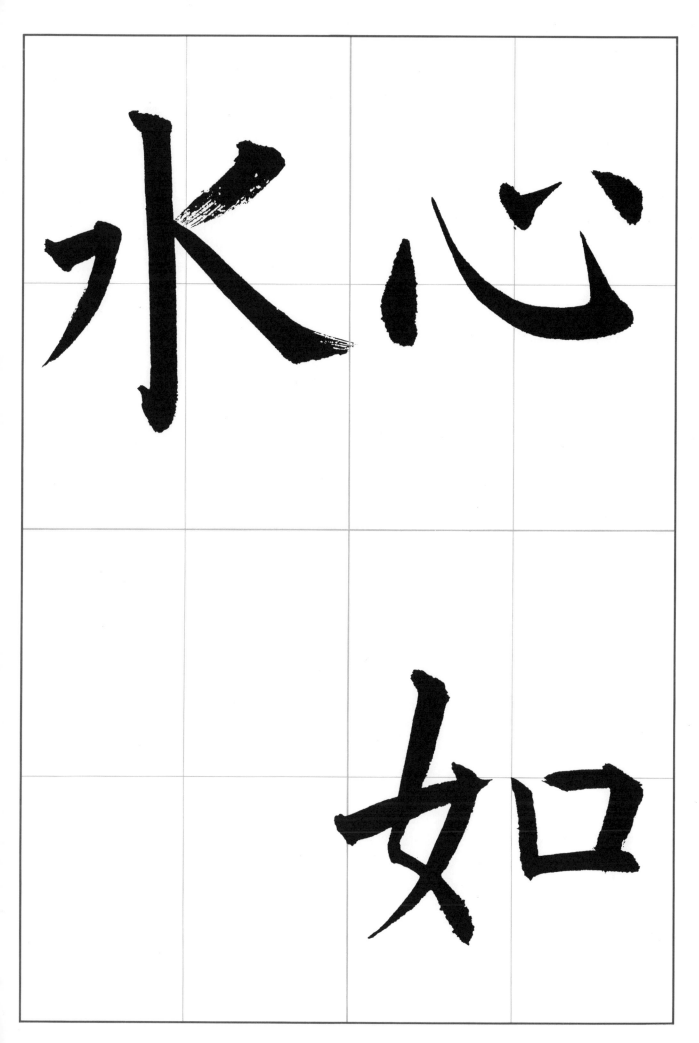

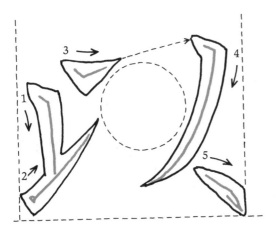

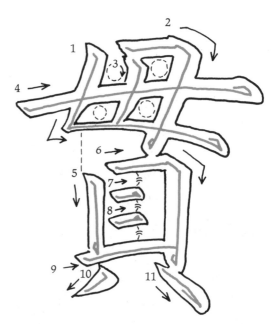

以 POINTS TO NOTE

2: Sword blade.

3: Apply the brush obliquely and bound for 4.

4: Inverse sword blade.

5: Dot. Write boldly but carefully.

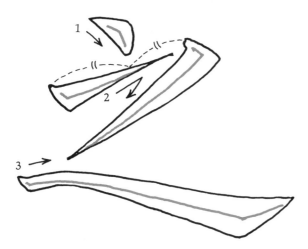

貫 POINTS TO NOTE

1: Vertical leg and horizontal leg. Making the line thinner around the corner gives the character a lighter feeling.

2 & 6: Horizontal and vertical legs. Stop the brush completely at the corners.

10: Dragon's claw.

11: Dot. Write boldly but carefully.

Note the spacing.

之 POINTS TO NOTE

1: Dot.

2: Sword blade and inverse sword blade. This is written as one stroke, though a break occurs at the corner.

3: Spatula.

一 POINTS TO NOTE (See horizontal line, p. 21.)

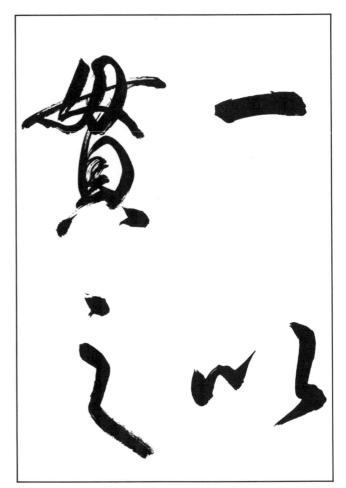

一以貫之 written in Semicursive Script.

一 **Readings:** ICHI, *hitotsu*.

Meanings: one, single.

以 **Readings:** I, *motte*.

Meanings: by means of.

貫 **Readings:** KAN, *tsuranuku*.

Meanings: penetrate, attain, carry through.

之 **Readings:** SHI, *kore*.

Meanings: this.

These words are put together as a motto, *Ichi motte kore [o] tsuranuku*, which means "Once started, follow through!"

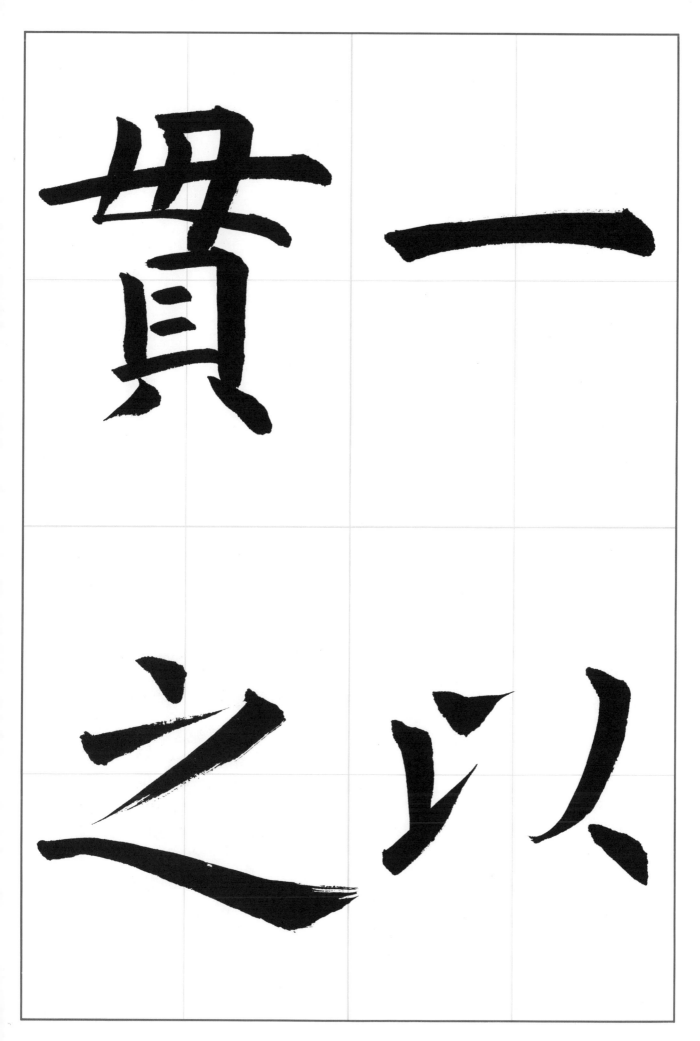

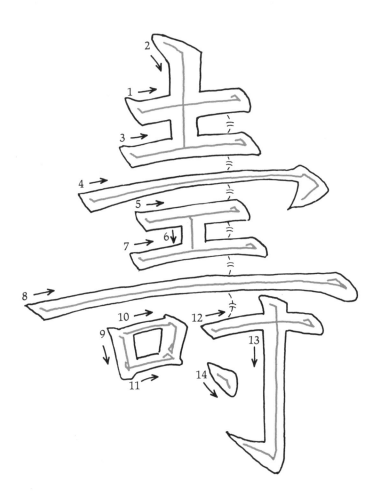

壽 POINTS TO NOTE

4: See 雲 (p. 32).

13: Vertical line and tail.

14: Dot.

Horizontal lines are slightly thinner than vertical.

Horizontal spacing is almost equal.

壽 **Readings:** JU, *kotobuki*.

Meanings: congratulations, felicitations.

寿 is in general use as the simplified form of this character. The complicated form is seen mostly in calligraphy.

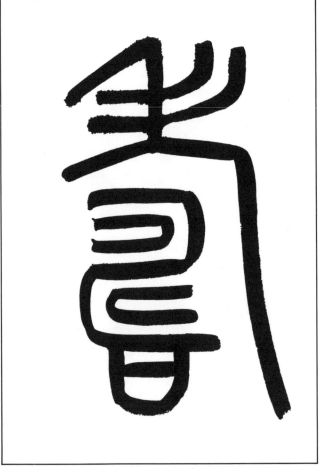

壽 written in Seal Script.

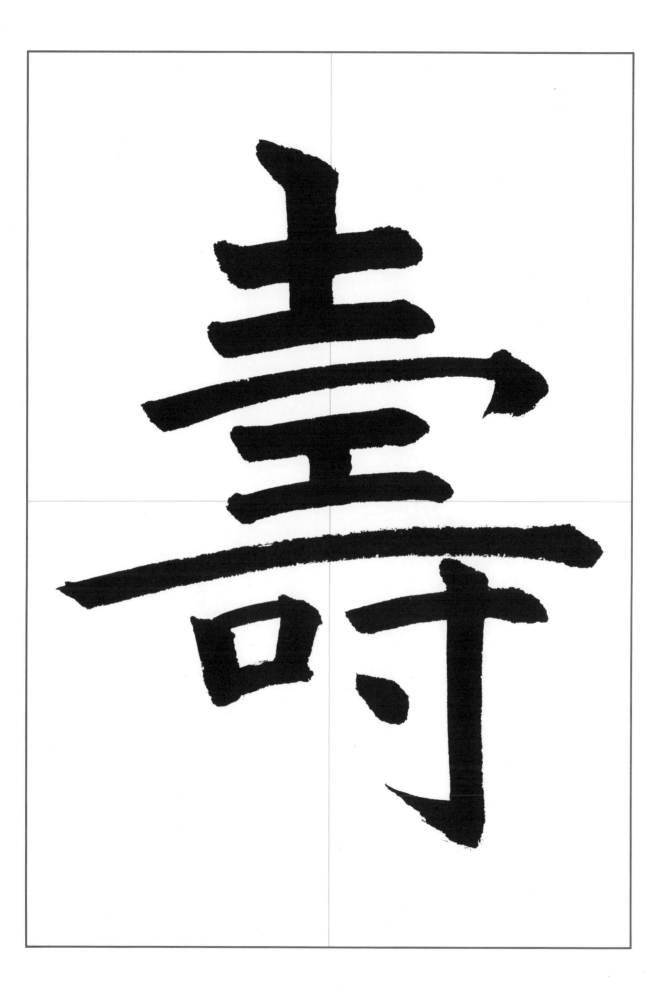

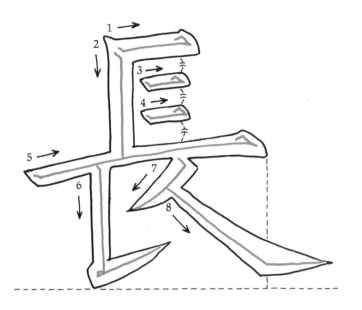

長 POINTS TO NOTE

6: Vertical line and sword blade.

7: Dragon's claw.

8: Spatula.

Space horizontal lines almost equally.

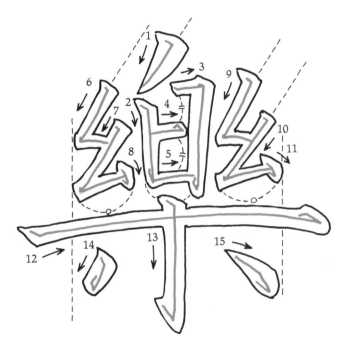

樂 POINTS TO NOTE

1: Dragon's claw.

3: Horizontal leg and vertical leg. Stop the brush at the corner.

6 & 7, 9 & 10: Vertical and horizontal lines. Write the strokes in the proper directions, as indicated. Stop the brush completely at each corner.

8, 11, 14, 15: Dots.

13: Vertical line and tail.

長 **Readings:** CHŌ, *nagai*.

Meanings: long, lengthy.

樂 **Readings:** RAKU, *tanoshii*.

Meanings: comfort, relief, pleasant, joyful.

Although not in common usage, these two characters (pronounced *chōraku*) have the meaning "long happiness." The character for *raku* used here is the original form of the simplified version (楽) that is commonly used today.

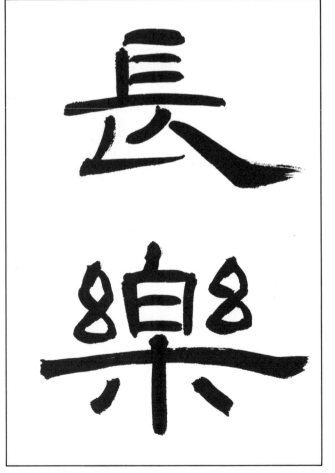

長樂 written in Clerical Script.

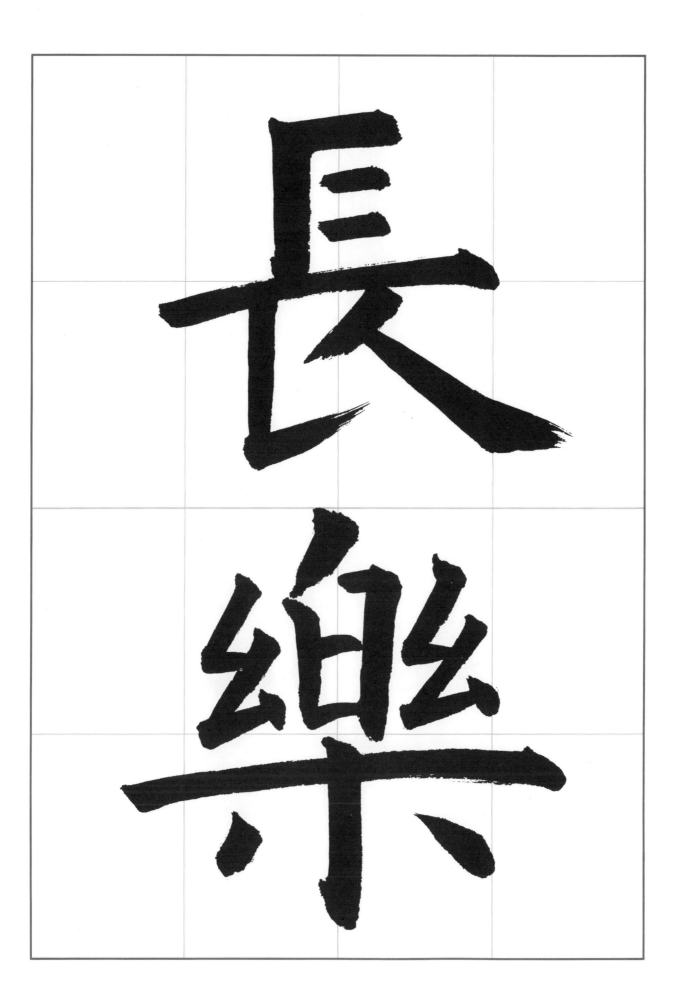

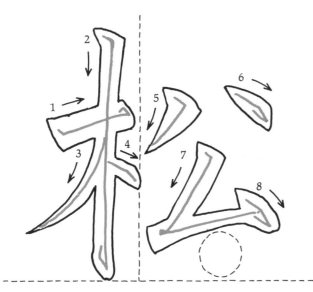

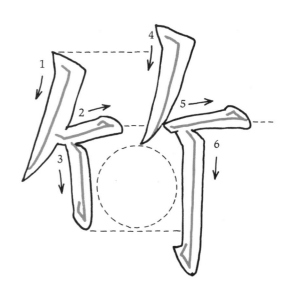

松 POINTS TO NOTE

3: Inverse sword blade.

4 & 6: Dots.

5: Dragon's claw.

7: Vertical and horizontal legs. Make a full stop at the corner.

8: Dot. Write boldly but carefully.

竹 POINTS TO NOTE

1 & 4: Dragon's claws.

6: Vertical line and tail.

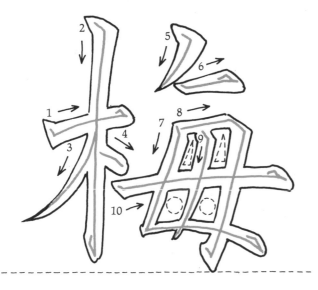

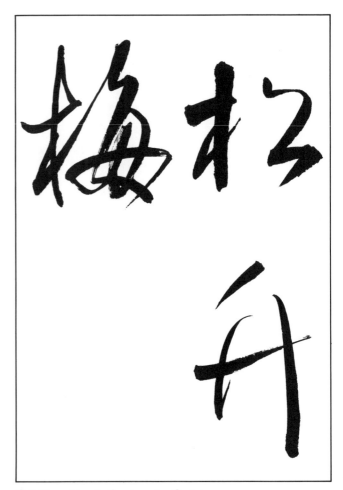

梅 POINTS TO NOTE

1–4: Same as left side of 松 (this page).

5: Dragon's claw.

7–10: See 貫 (p. 48), strokes 1–4.

松 **Readings:** SHŌ, *matsu*.
Meanings: pine tree.

竹 **Readings:** CHIKU, *take*.
Meanings: bamboo.

梅 **Readings:** BAI, *ume*.
Meanings: apricot tree (commonly, plum tree).

Pine and bamboo are resistant to the cold, and the apricot tree blossoms before the frost is off the ground. *Shōchikubai* is an auspicious phrase symbolizing longevity and happiness.

松竹梅 written in Semicursive Script.

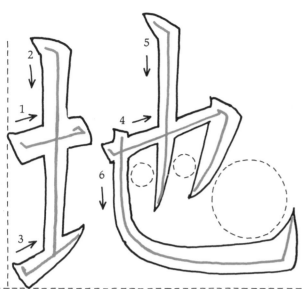

地 POINTS TO NOTE
3: Sword blade.
4: Horizontal and inclined vertical leg.
5: Vertical line. Complete strokes 4 and 5 by calmly lifting the brush, making the lines thinner.
6: This stroke is the same as the last stroke of 色 (p. 31).
Vertical spaces on the right are almost equal.

和 POINTS TO NOTE
1: Dragon's claw.
2-5: See p. 54, left side of 松.
7: Horizontal leg and vertical leg. Full stop at the corner.

天 POINTS TO NOTE (See p. 30.)

清 POINTS TO NOTE (See p. 38.)

地 **Readings:** CHI, *tsuchi*.
Meanings: earth, ground, land.

和 **Readings:** WA, *yawaragu*
Meanings: peace, harmony, reconciliation.

Combined to read *tenchiseiwa*, these characters mean "Heaven and earth [i.e., nature] are clean and peaceful."

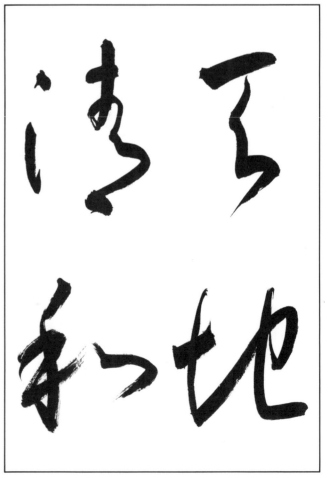

天地清和 written in Cursive Script.

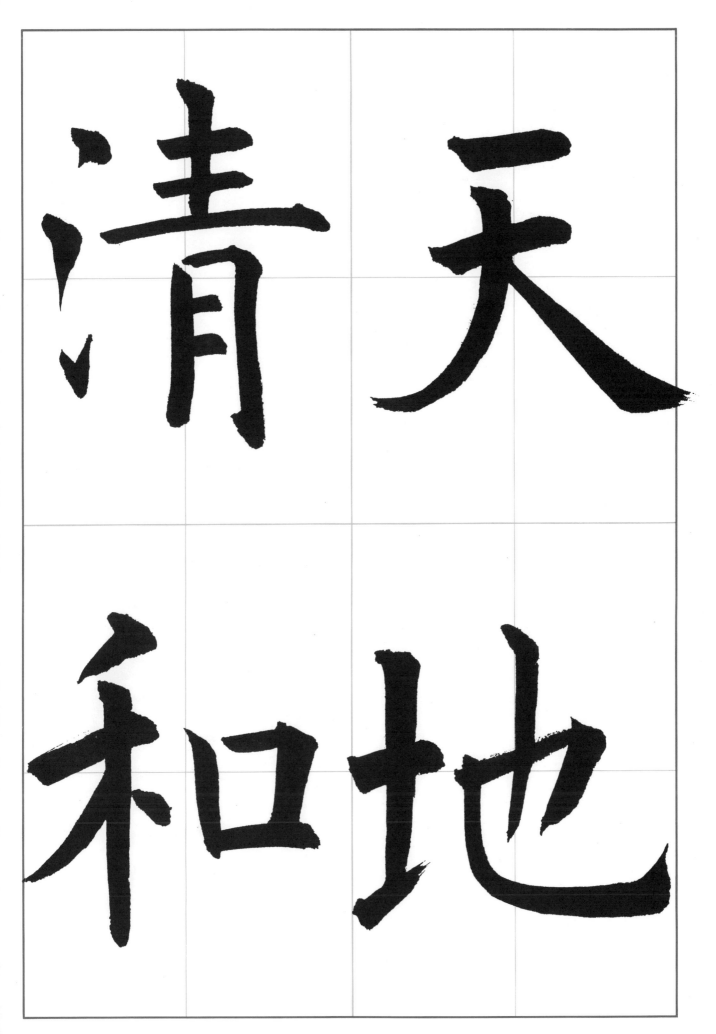

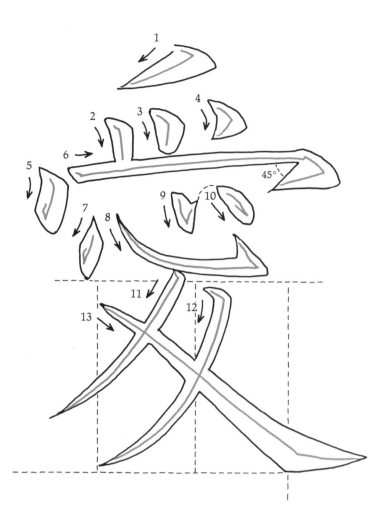

愛 POINTS TO NOTE

1: Dragon's claw.

2–4: Dots. From last dot move directly to next stroke.

5 & 6: See 雲 (p. 32).

7–10: See 心 (p. 46).

11: Inverse sword blade.

12: Short horizontal leg and inverse sword blade.

13: Spatula.

Readings: AI.

Meanings: love, admire, appreciate.

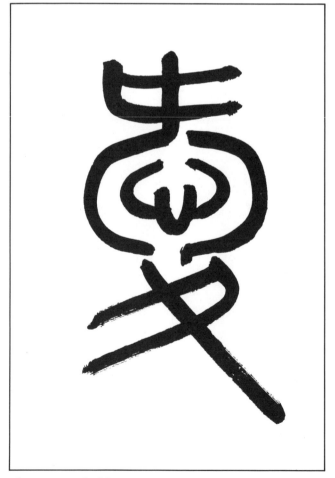

愛 written in Seal Script.

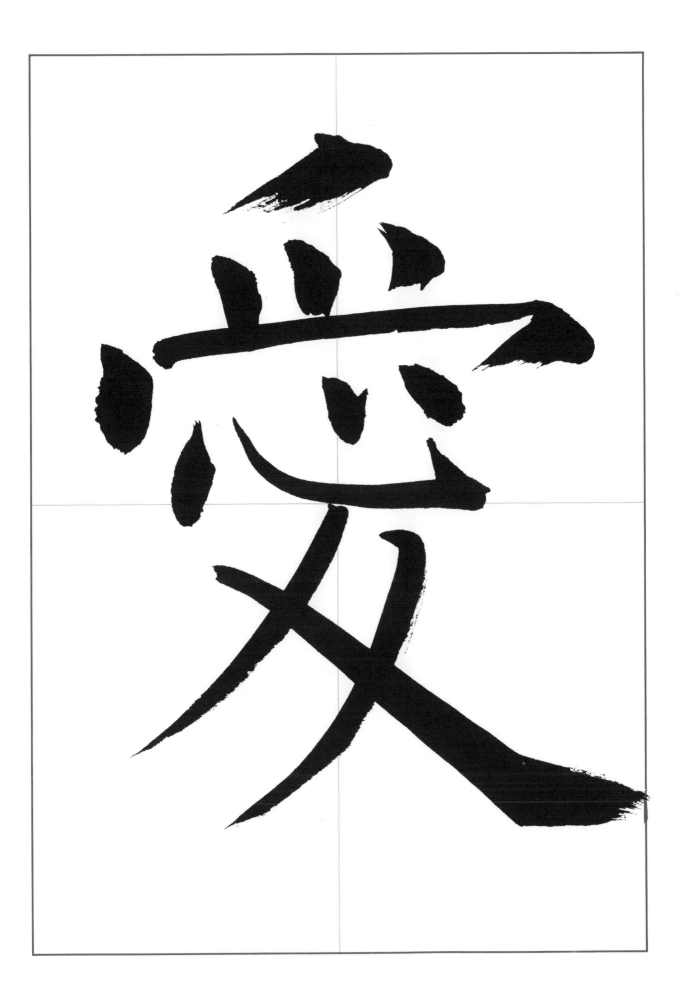

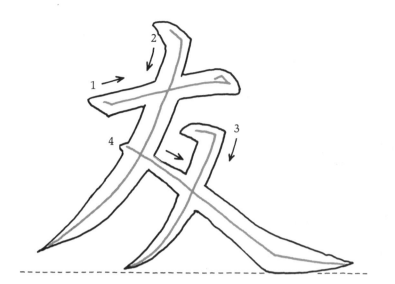

友 POINTS TO NOTE
2: Inverse sword blade.
3: Short horizontal leg and inverse sword blade.
4: Spatula.

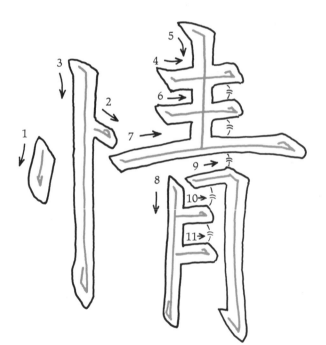

情 POINTS TO NOTE
4–11: See 清 (p. 38).

友 **Readings:** YŪ, *tomo*.
Meanings: friend.

情 **Readings:** JŌ, *nasake*.
Meanings: feeling, human nature, sympathy, compassion.

These characters combine to form *yūjō*, "friendship."

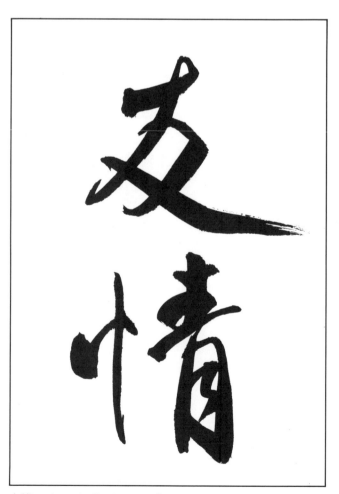

友情 written in Semicursive Script.

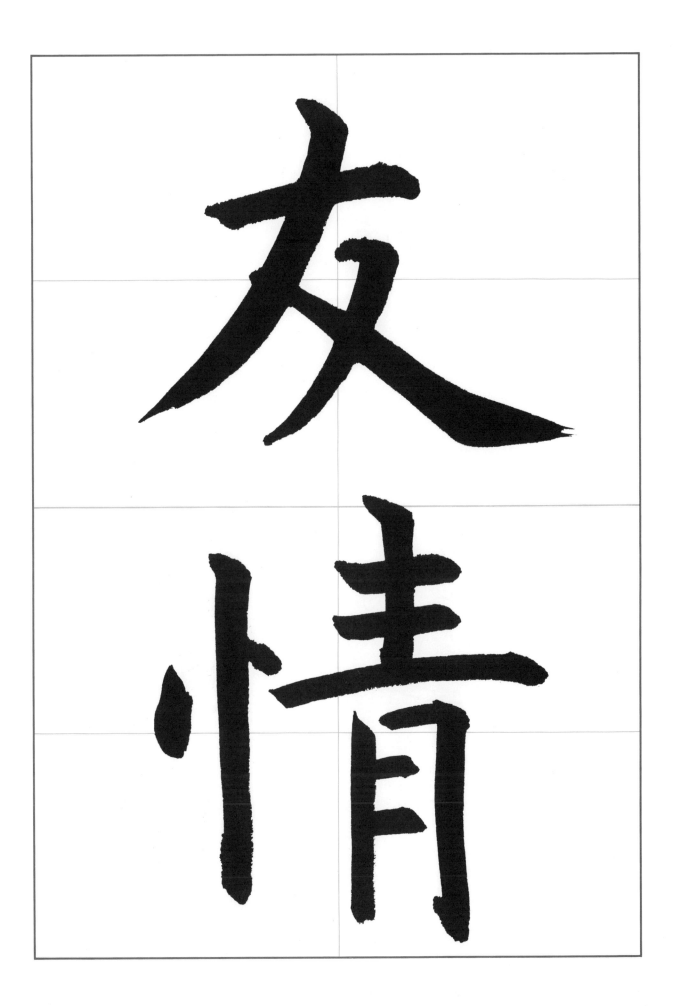

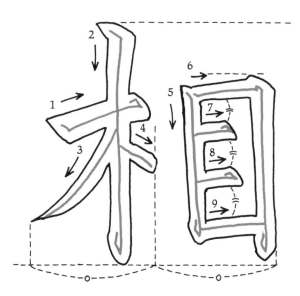

相 POINTS TO NOTE

1–4: See 松 (p. 54).

6: Horizontal and vertical legs. Stop completely at the corner. Horizontal spacing is almost equal.

相 **Readings:** SŌ, *ai*.

Meanings: aspect, each other, reciprocally.

思 **Readings:** SHI, *omou*.

Meanings: think, believe, realize.

Sōshi is made by combining these two characters and means "mutual respect."

思 POINTS TO NOTE

2: Horizontal and vertical legs. Stop at the corner. Line 1 and the vertical leg of line 2 should slant slightly inward. The spaces surrounded by lines 1 to 5 are almost equal.

6–9: See 心 (p. 46).

相思 written in Cursive Script.

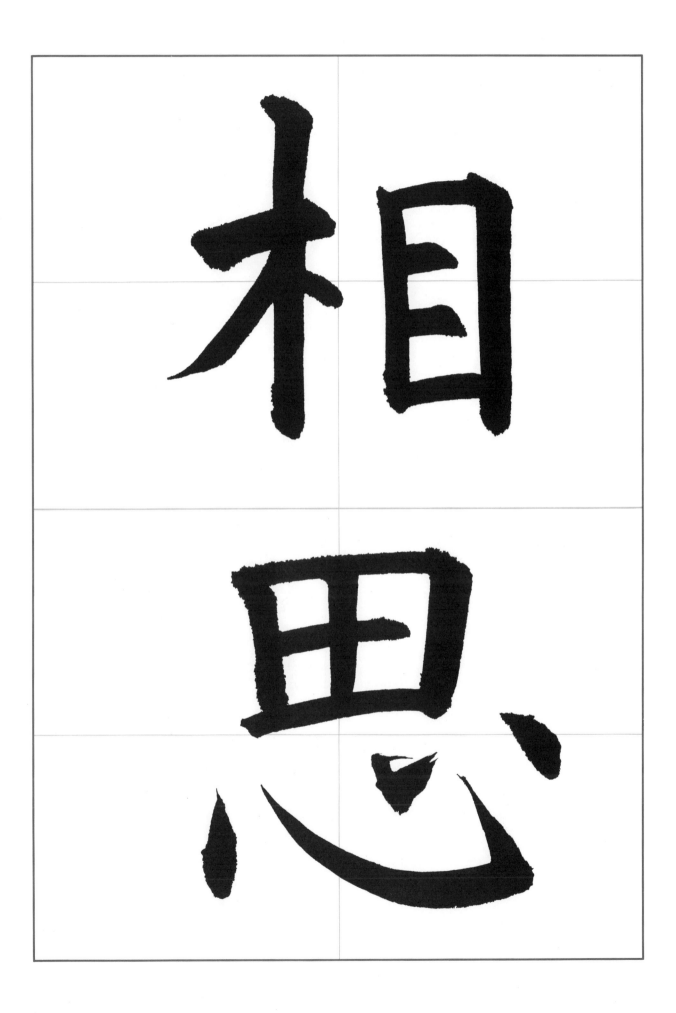

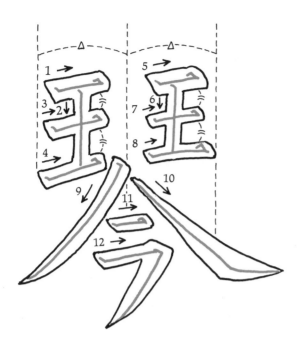

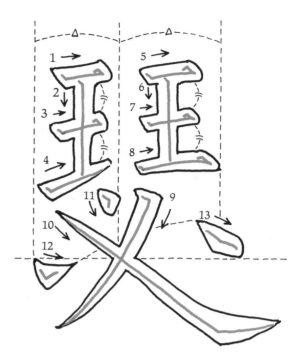

琴 POINTS TO NOTE

9: Inverse sword blade.

10: Spatula.

12: Horizontal line and dragon's claw.

Give horizontal lines at top the same slant, and space evenly.

相 POINTS TO NOTE (See p. 62.)

和 POINTS TO NOTE (See p. 56.)

琴 **Readings:** KIN, *koto*.

Meanings: *koto*, Japanese zither.

瑟 **Readings:** SHITSU, *ōgoto*.

Meanings: *ōgoto*, large Japanese zither.

Kinshitsu aiwa [su] means that large and small zithers play together harmoniously. So, too, should husband and wife.

瑟 POINTS TO NOTE

9: Inverse sword blade.

10: Spatula.

11–13: Dots. Pay special attention to direction. With 12, apply the brush obliquely, push, and bound for 13.

Horizontal strokes are all evenly spaced.

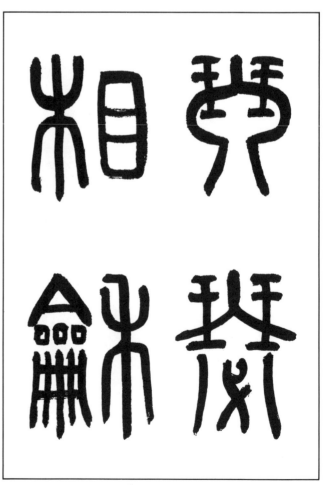

琴瑟相和 written in Seal Script.

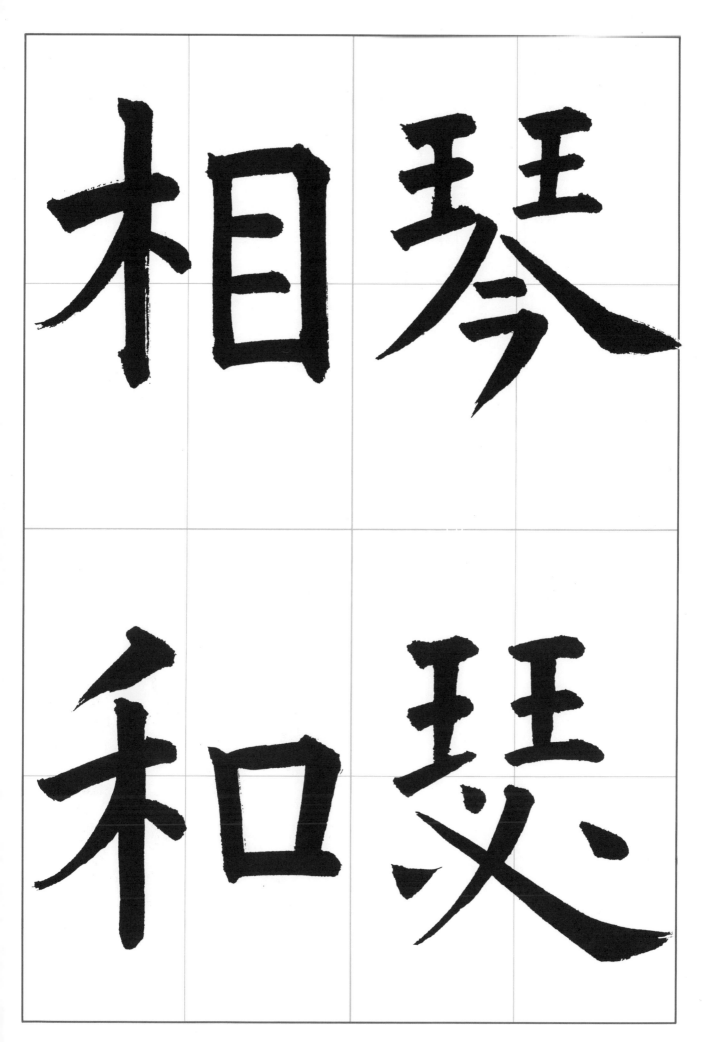

相琴
和瑟

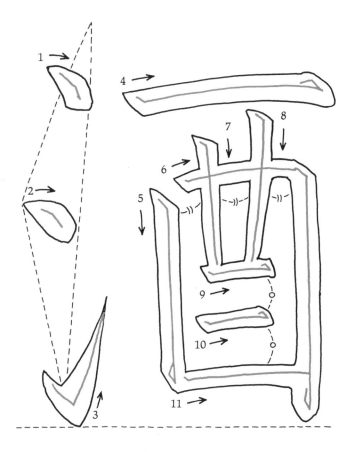

酒 POINTS TO NOTE

1 & 2: Dots.

3: Apply the brush obliquely, push, and bound up for 4.

6: Horizontal and vertical legs. Stop at the end of the horizontal line, then move downward.

7 & 8: These vertical lines grow thinner toward the bottom, the spaces around them opening slightly.

酒 **Readings:** SHU, *sake*.
Meanings: sake, spirits.

酒 written in Cursive Script.

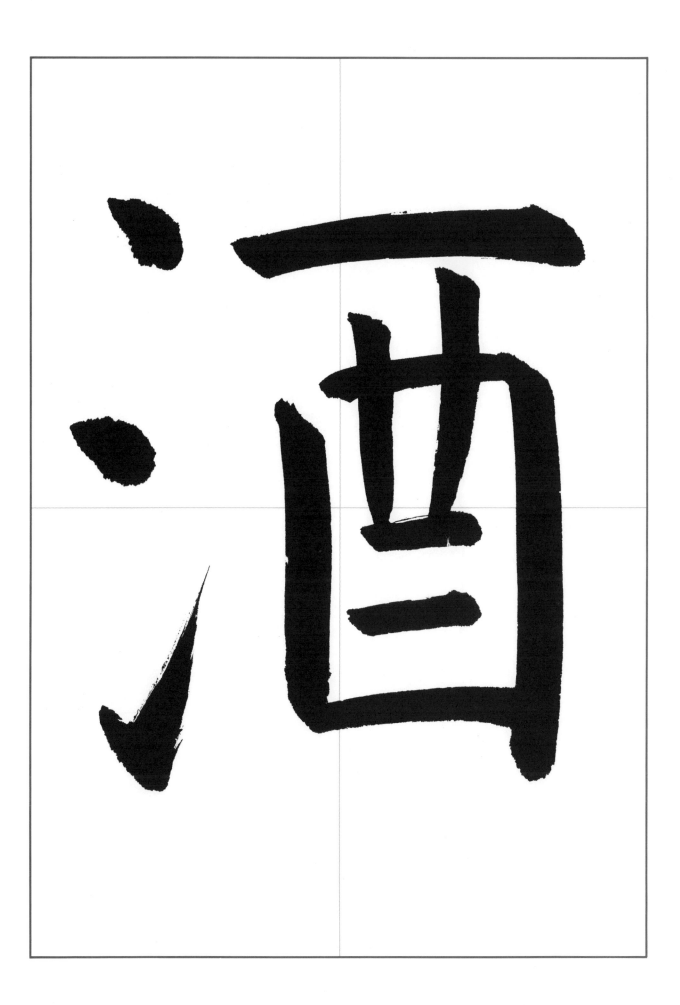

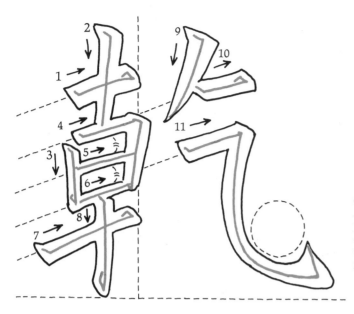

乾 POINTS TO NOTE
9: Dragon's claw.
11: Horizontal line and last stroke of 色 (p. 31).
Horizontal lines on the left side are evenly spaced and slant slightly upward, as do the horizontal lines on the right side.

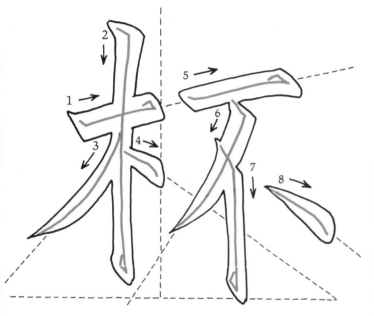

杯 POINTS TO NOTE
1–4: See left side of 松 (p. 54).
3 & 6: Inverse sword blades.
8: Dot. Elongate slightly and stop completely at the end.
Take particular care with the direction of each stroke.

乾 **Readings:** KAN, *kawakasu*.
Meanings: dry, desiccate.

杯 **Readings:** HAI/PAI, *sakazuki*.
Meanings: sake cup, glass, glassful, toast.

Kanpai is a toast: "Drink up!" "Cheers!"

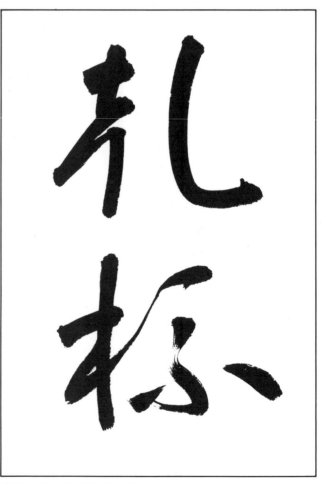

乾杯 written in Cursive Script.

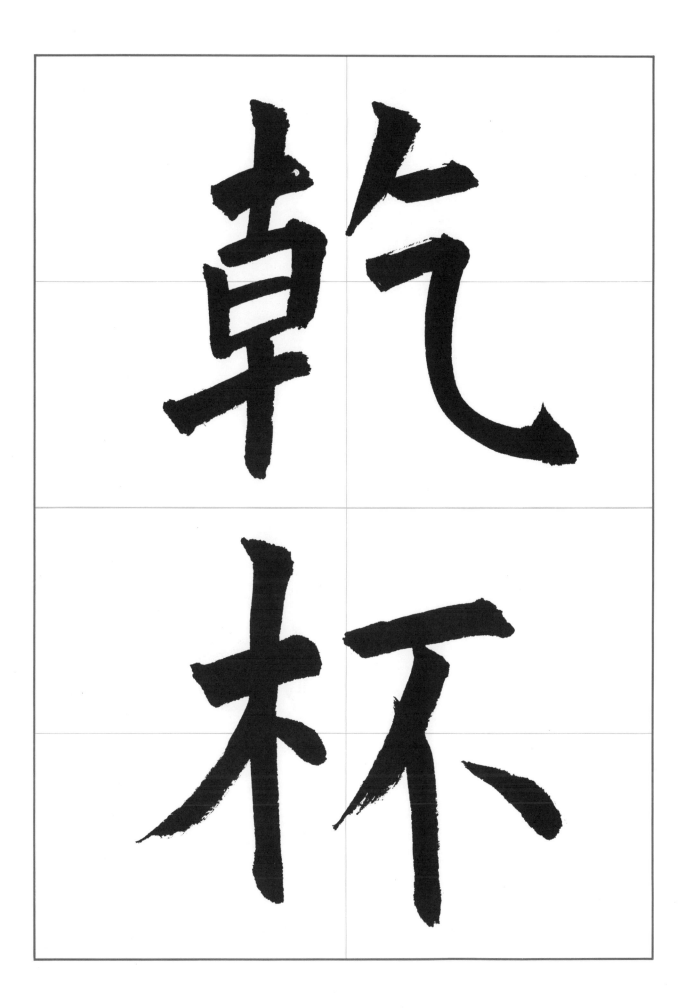

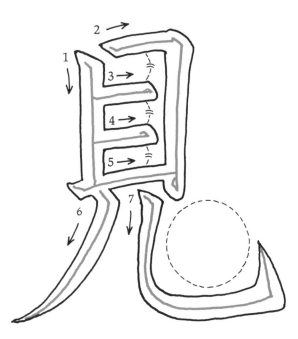

見 POINTS TO NOTE

2: Horizontal and vertical legs. Come to a full stop at the end of the horizontal leg.

6: Inverse sword blade.

7: See 色 (p. 31).

Space horizontal lines evenly.

花 POINTS TO NOTE (See p. 34.)

酒 POINTS TO NOTE (See p. 66.)

見 **Readings:** KEN, *miru*.

Meanings: look, sight, see, examine.

A cheerful way to enjoy "sake" is while "viewing the [cherry] blossoms." In Japanese, *hanami-zake*.

花見酒 written in Cursive Script.

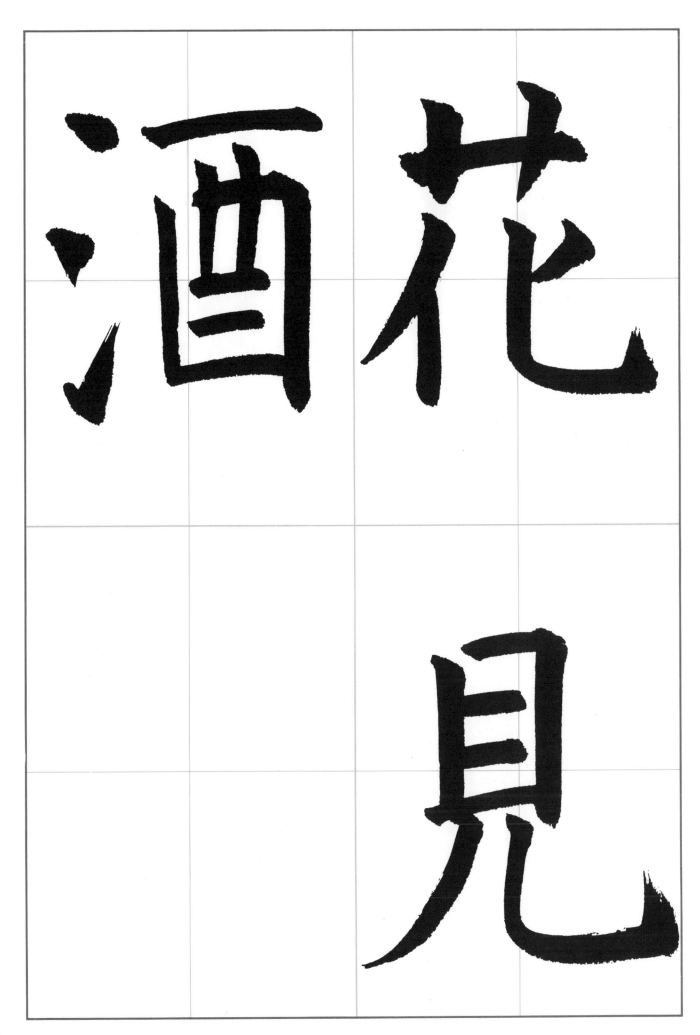

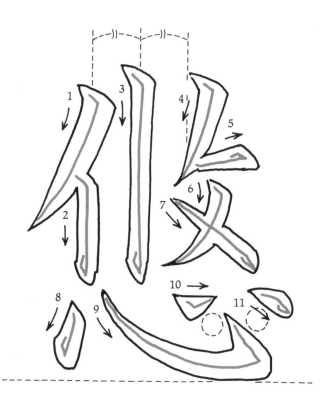

悠 POINTS TO NOTE
1 & 4: Inverse sword blades.
6: Dragon's claw.
8–11: See 心 (p. 46).
Vertical spaces should be uniformly even.

⟨ POINTS TO NOTE
1–2: Two dots. Apply the brush obliquely, then spring for 2, attending to direction. Place in center of the space.

樂 POINTS TO NOTE (See p. 52.)
酒 POINTS TO NOTE (See p. 66.)

悠 **Readings:** YŪ, *haruka*.
Meanings: distant, longtime, leisure.

⟨ No reading of its own. A ditto mark, it calls for a repetition of the pronunciation and meaning of the preceding character.

The phrase *rakushu yūyū* evokes the image of drinking "sake cheerfully and calmly."

樂酒悠 ⟨ written in Cursive Script.

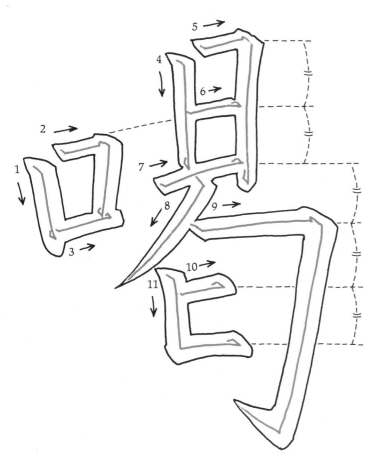

喝 POINTS TO NOTE

2 & 5: Horizontal and vertical legs. Come to a full stop at each corner.

8: Inverse sword blade.

9: Horizontal and vertical legs with tail. Stop at each corner. Slant vertical leg slightly inward.

11: Vertical and horizontal legs.

Horizontal spaces should be uniformly even.

Readings: KATSU.

Meanings: shout.

A Zen priest uses the word, or the shout, *katsu* to encourage his acolytes.

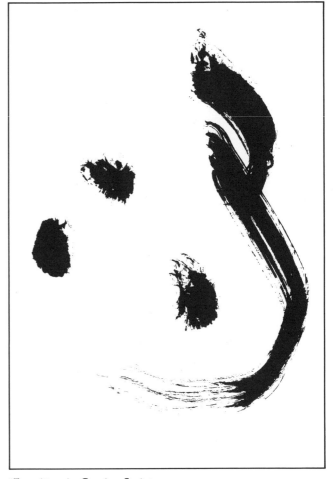

喝 written in Cursive Script.

74

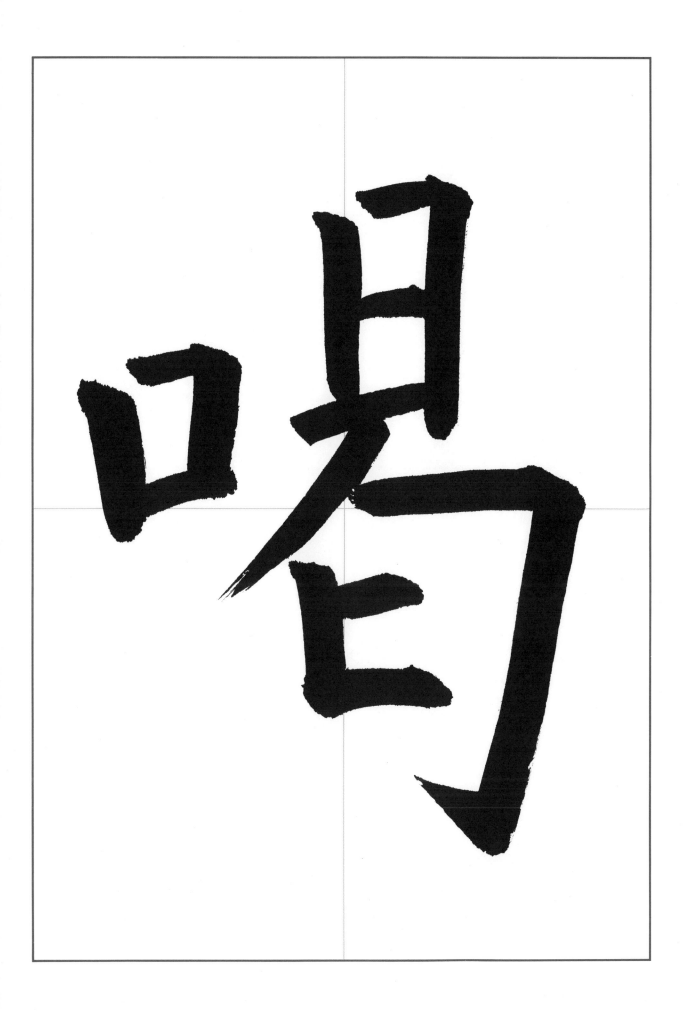

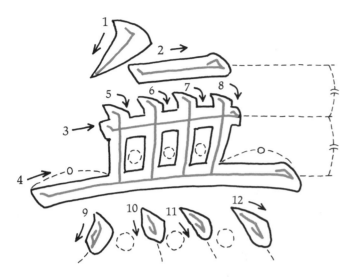

無 POINTS TO NOTE

1: Dragon's claw.

9–12: Dots. Dot 9 faces left, the other three right.

Horizontal and vertical spaces should be about the same.

無 **Readings:** MU, *nai*.

Meanings: none, nil, negation.

我 **Readings:** GA, *ware*.

Meanings: ego, self, I, oneself.

Combined in the term *muga*, these characters mean "selflessness."

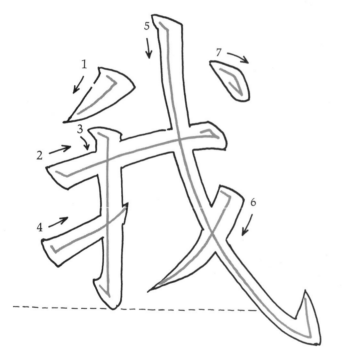

我 POINTS TO NOTE

1 & 6: Dragon's claws.

3: Vertical line and tail.

4: Sword blade.

5: Similar to the last stroke of 色 (p. 31).

7: Dot.

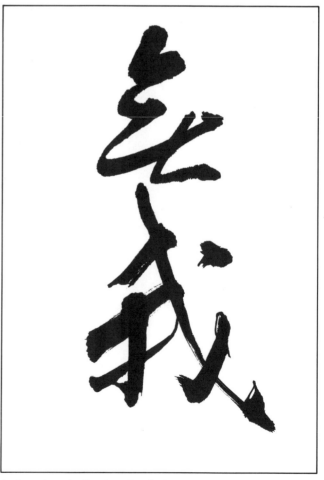

無我 written in Semicursive Script.

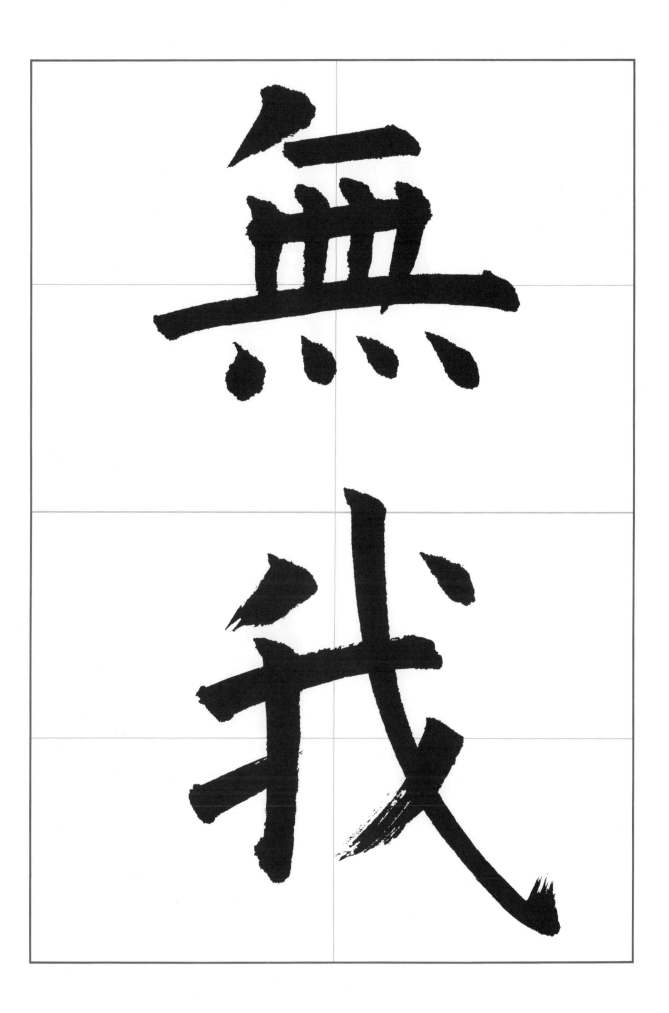

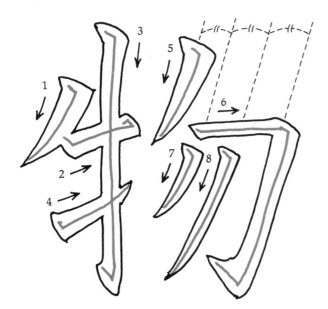

物 POINTS TO NOTE

1, 5 & 7: Dragon's claws.

3: Vertical line and tail.

4: Sword blade.

6: Horizontal and vertical legs with tail. The vertical leg slants slightly inward.

8: Inverse sword blade.

Take note of the horizontal and vertical spaces.

無 POINTS TO NOTE (See p. 76.)

一 POINTS TO NOTE (See horizontal line, p. 21.)

一 **Readings:** ICHI, *hitotsu*.

Meanings: one, single.

物 **Readings:** MOTSU, BUTSU, *mono*.

Meanings: thing, object, matter.

Muichi motsu is a way of saying "To have nothing."

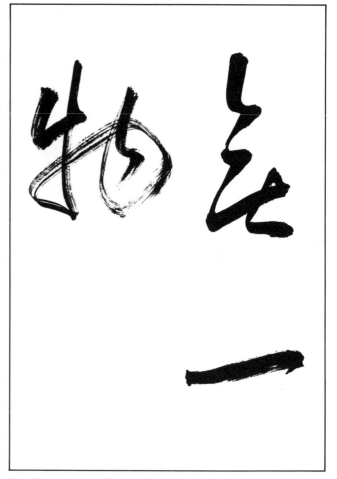

無一物 written in Cursive Script.

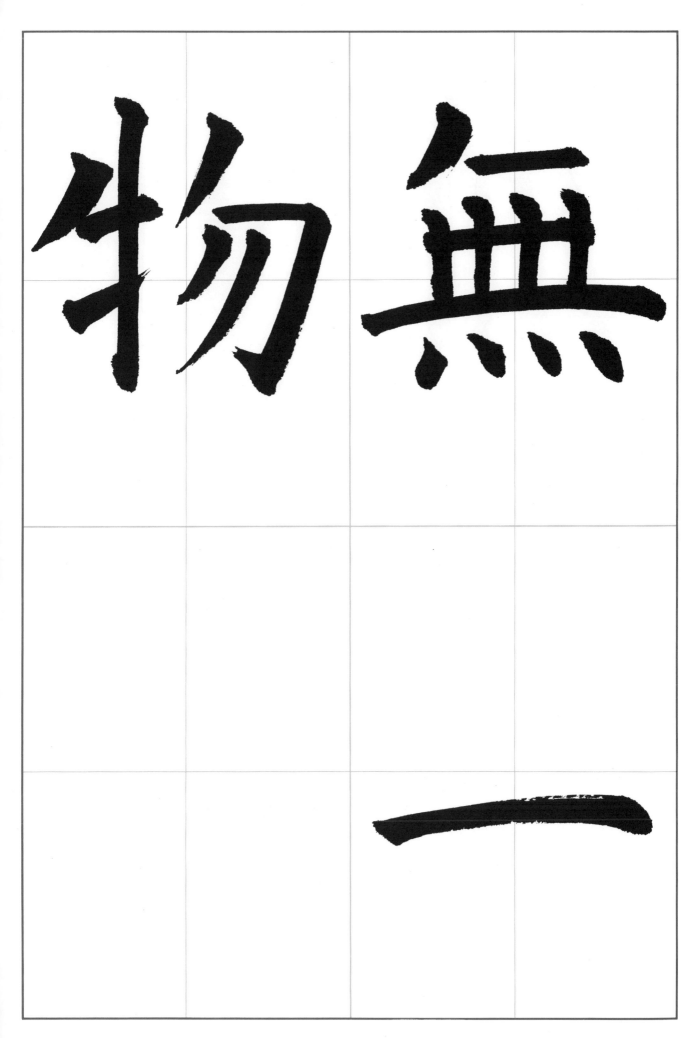

無物一

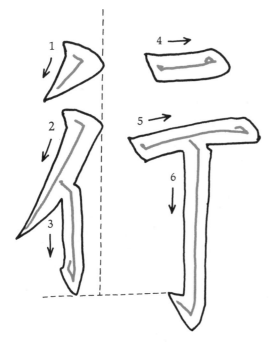

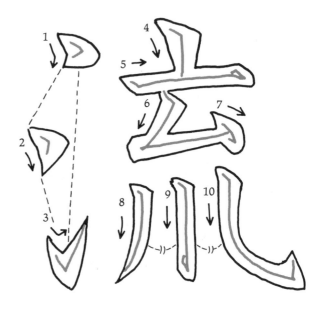

行 POINTS TO NOTE
1: Dragon's claw.
2: Inverse sword blade.
6: Vertical line and tail.

雲 POINTS TO NOTE (See p. 32.)
水 POINTS TO NOTE (See 永, p. 26.)

流 POINTS TO NOTE
1–3: See 清 (p. 38).
4: Dot.
6: Vertical and horizontal legs. Come to a full stop at the corner.
7: Dot.
8: Inverse sword blade.
10: Similar to the last stroke of 色 (p. 31).

行 **Readings:** KŌ, GYŌ, *iku*, *yuku*, *okonau*.
Meanings: journey, line, go, run, act, perform, conduct.

流 **Readings:** RYŪ, *nagareru*.
Meanings: current, flow, wander, wash away.

The literal meaning of *kōunryūsui* is "floating clouds and running water." Metaphorically it suggests living in a calm and natural manner.

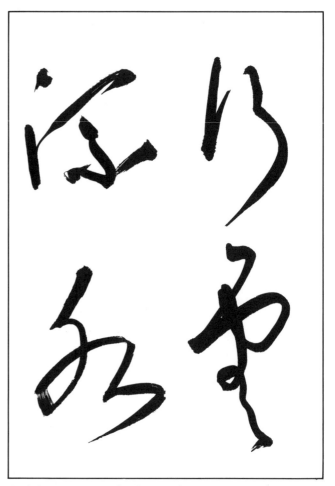

行雲流水 written in the Cursive Script.

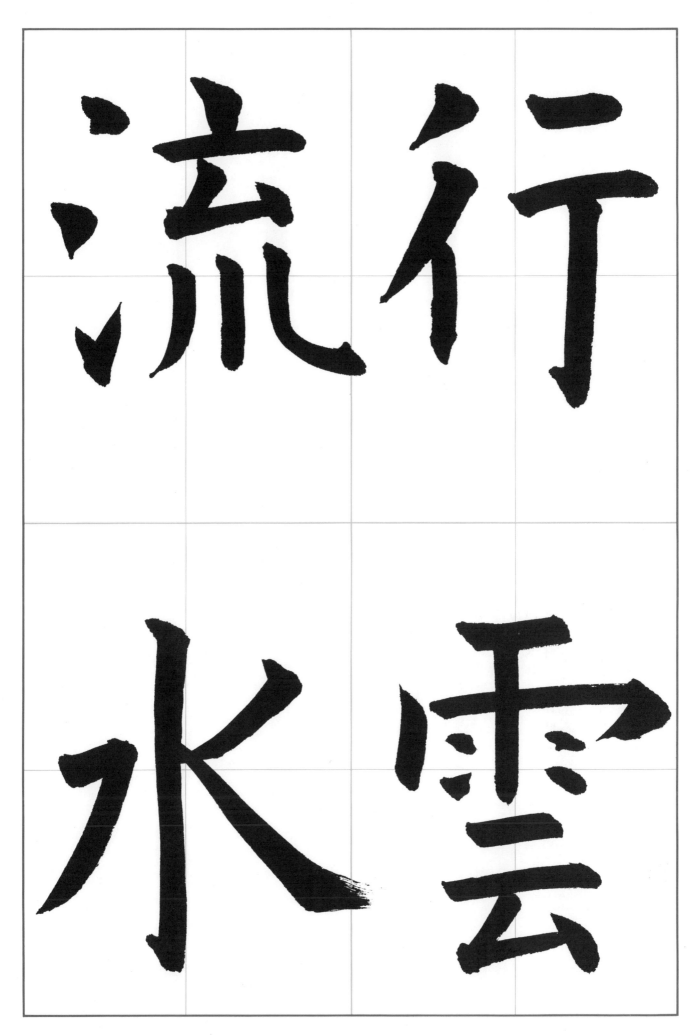

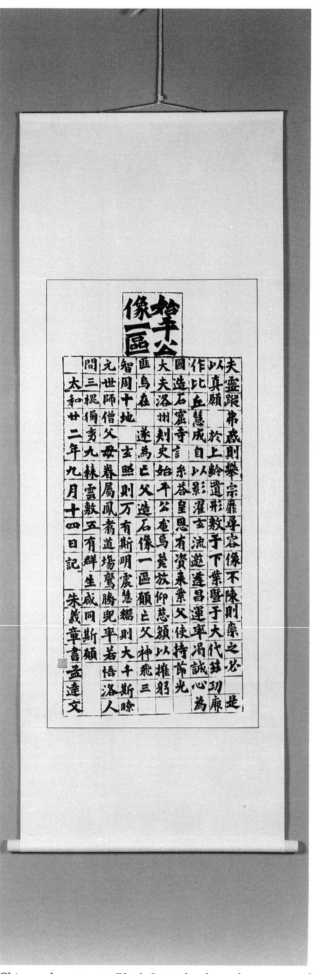

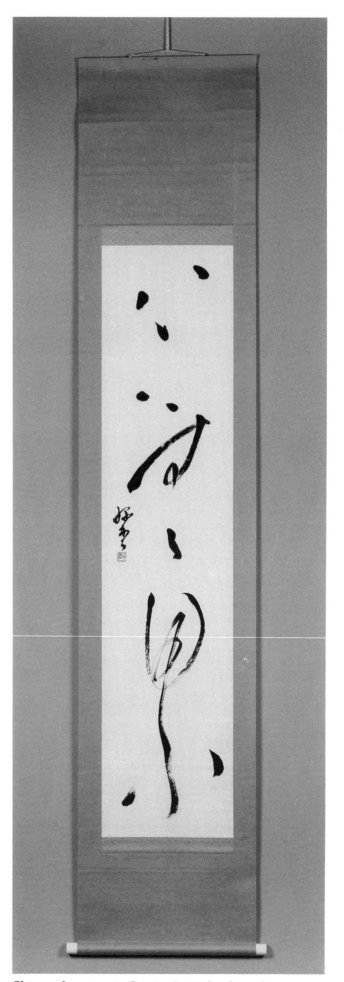

Chinese characters in Block Script by the author, mounted on a hanging scroll.

Chinese characters in Cursive Script by the author, mounted on a hanging scroll.

Writing the Japanese Alphabet

The most important characteristic of *hiragana* brushwork is the rhythmical sweep and flow of its rounded lines. To bring this out fully and to the best effect, you should keep the following points in mind.

1. Basically, *hiragana* brushwork is the same as that for Chinese characters.
2. Use a small brush, softening the top 5 mm. or so of the brush. Use only the softened part of the bristles.
3. When you write *hiragana*, use paper that does not bleed.
4. Pay particular attention to the form of the model, reproducing it as accurately as you can.
5. Apply the tip of the brush very lightly at the beginning of the first stroke.
6. When stopping the tip of the brush at the end of a character, stop it lightly but with feeling, moving on to the next character. The overall feeling of continuity is of utmost importance.

The *iro ha* arrangement in which this syllabary is given on the following pages is the traditional order for *hiragana*. Start at the upper right of page 85, move downward and then to the next row on the left. A few characters are no longer used, except by calligraphers for decorative or other purposes, and these are so indicated.

"Iro ha" is a poem popularly ascribed to the famous priest Kūkai (774–835). As translated by Basil Hall Chamberlain, it reads as follows:

> *Though gay in hue, [the blossoms] flutter down, alas!*
> *Who then, in this world of ours, may continue forever?*
> *Crossing today the uttermost limits of phenomenal existence,*
> *I shall see no more fleeting dreams, neither be any longer intoxicated.*

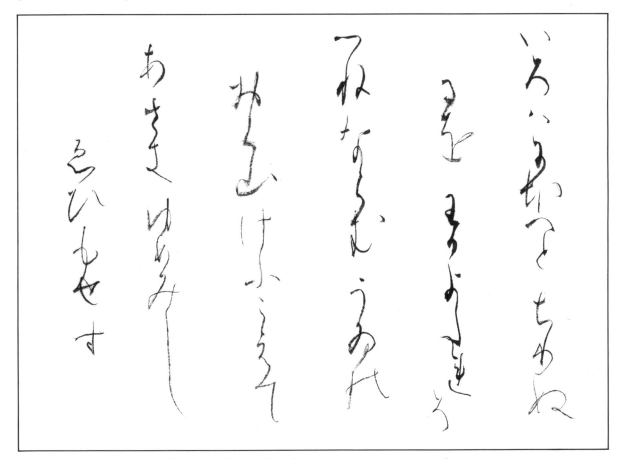

The poem "Iro ha" by the author in an artistic rendition.

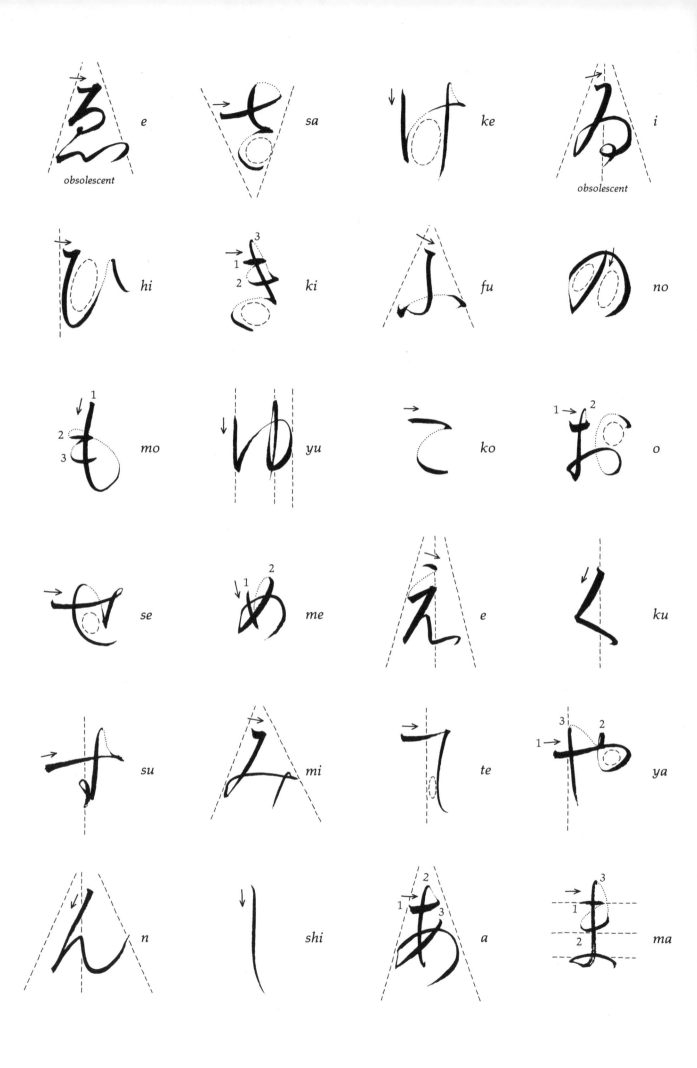

ゑ *e*
obsolescent

さ *sa*

け *ke*

み *i*
obsolescent

ひ *hi*

き *ki*

ふ *fu*

の *no*

も *mo*

ゆ *yu*

こ *ko*

お *o*

せ *se*

め *me*

え *e*

く *ku*

す *su*

み *mi*

て *te*

や *ya*

ん *n*

し *shi*

あ *a*

ま *ma*

84

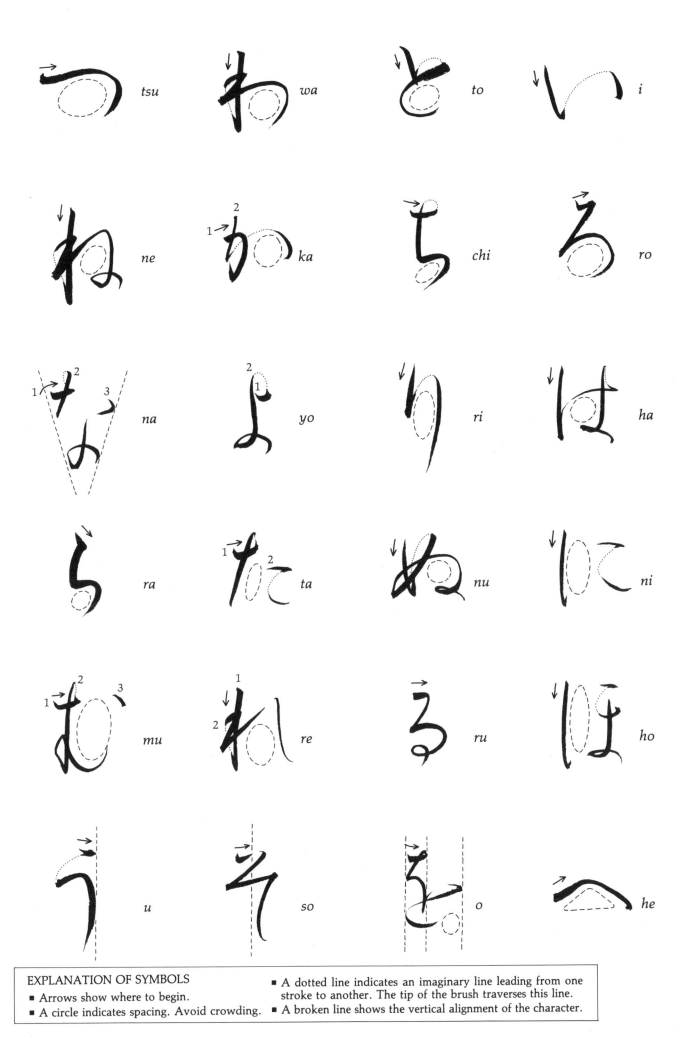

つ *tsu* わ *wa* と *to* い *i*

ね *ne* か *ka* ち *chi* ろ *ro*

な *na* よ *yo* り *ri* は *ha*

ら *ra* た *ta* ぬ *nu* に *ni*

む *mu* れ *re* る *ru* ほ *ho*

う *u* そ *so* を *o* へ *he*

EXPLANATION OF SYMBOLS
- Arrows show where to begin.
- A circle indicates spacing. Avoid crowding.
- A dotted line indicates an imaginary line leading from one stroke to another. The tip of the brush traverses this line.
- A broken line shows the vertical alignment of the character.

WORDS WRITTEN IN *HIRAGANA*

Examples have been marked to indicate whether they are standard ways of writing *hiragana*, whether they have been given an artistic shape, or whether they are creative interpretations.

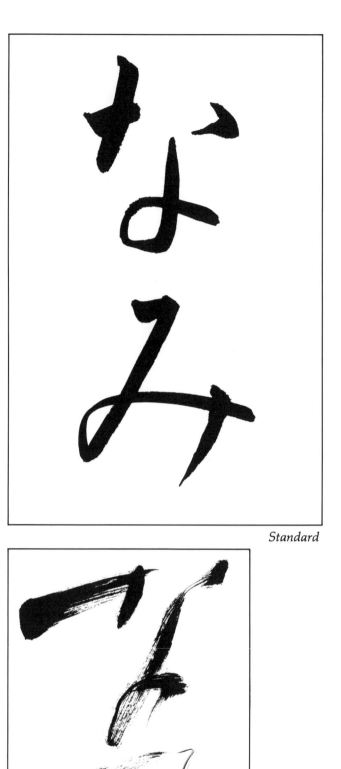

Standard

Artistic

なみ *nami*, wave

Creative

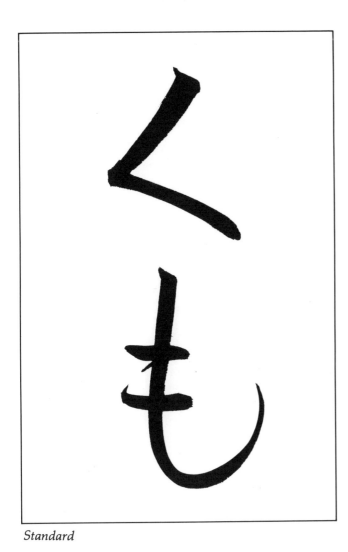

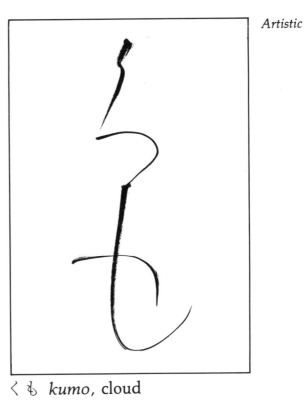

くも *kumo*, cloud

Standard

Artistic

Standard

かぜ *kaze*, wind

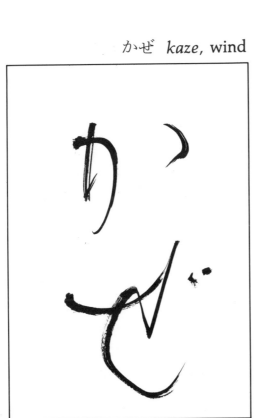

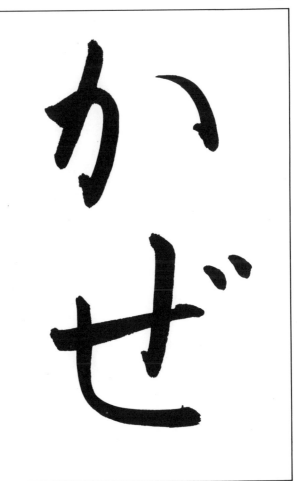

Artistic

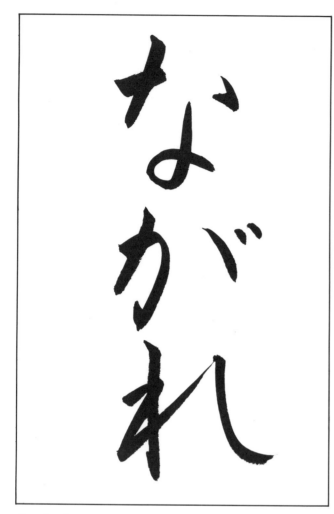

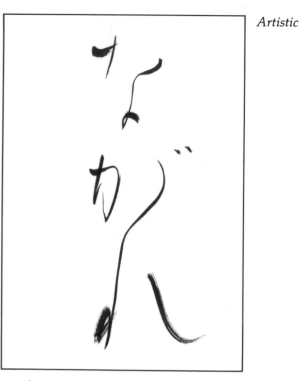

ながれ *nagare*, flowing

しぐれ *shigure*, late autumn shower

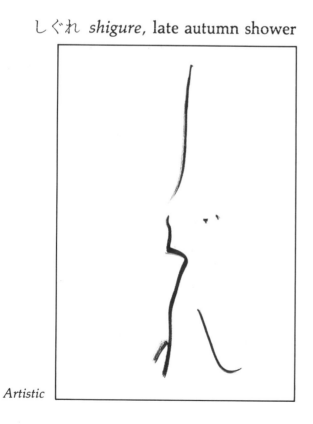

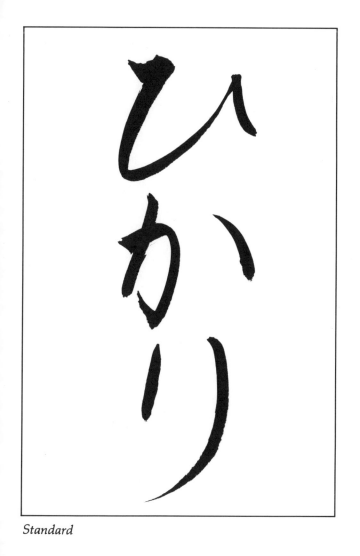

Standard

ひかり *hikari*, light

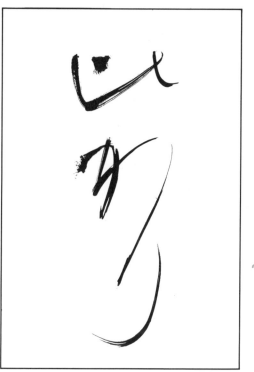

Artistic

Creative

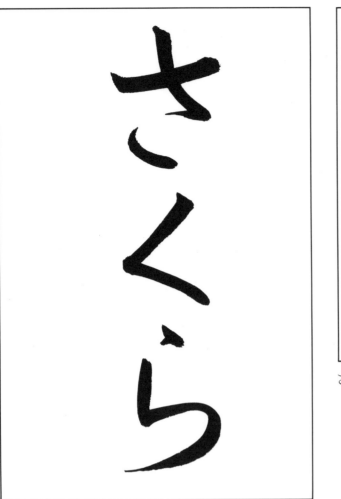

さくら *sakura*, cherry

わかれ *wakare*, farewell

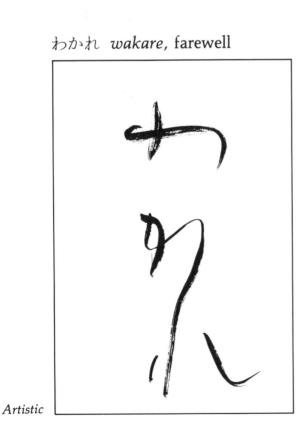

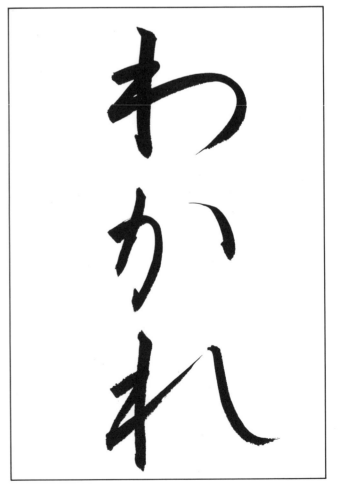

Calligraphy for Appreciation

These works were created to reflect the meaning of the character.

雨 (U, *ame*), rain: written to create the impression of a
light rain. Light ink.

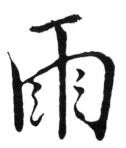

"Rain" written in Semicursive Script
by Wang Duo (1592–1652).

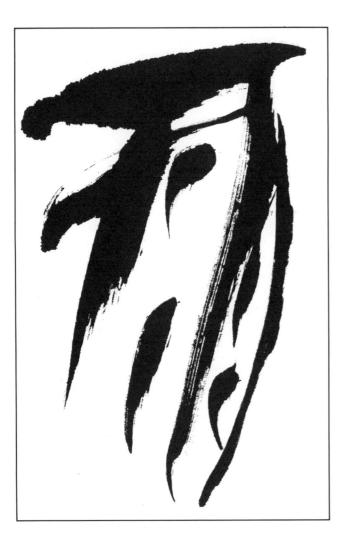

"Rain" written to suggest a torrential downpour.

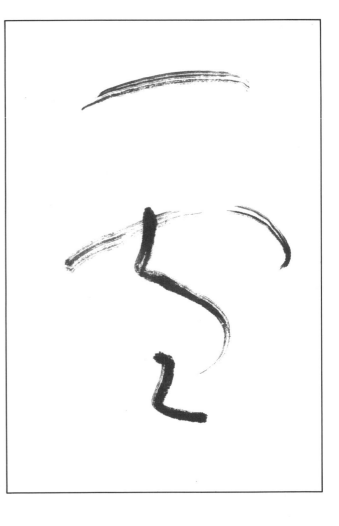

雪 (SETSU, *yuki*), snow: written to create the impression of a snowy sky. Light ink.

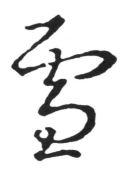

"Snow" written in Cursive Script by Wang Xizhi (307–65).

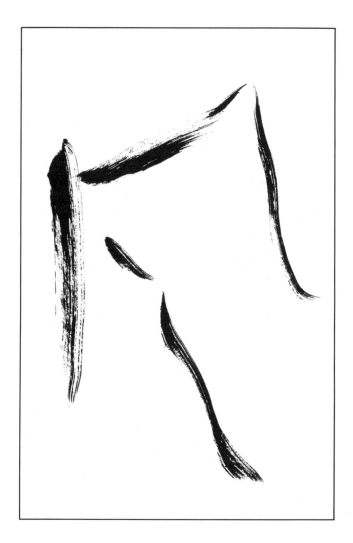

風 (Fū, *kaze*), wind: written to create the impression of a refreshing breeze.

"Wind" written to recreate the violence of a typhoon.

"Wind" written in Cursive Script by Huaisu (725?–86?).

雷 (RAI, *kaminari*), thunder: a recreation of the Seal Script.

"Thunder" as a pictograph from around 1500 B.C.

光 (KŌ, *hikari*), light: written to create the impression of a fountainhead of light.

"Light" as a pictograph from around 1500 B.C.

 寂 (SEKI, JAKU, *sabishii*), lonely, quiet, calm: written to reflect the serenity of the semicursive model. Light ink.

"Lonely" written in Semicursive Script by Huang Tingjian (1045–1105).

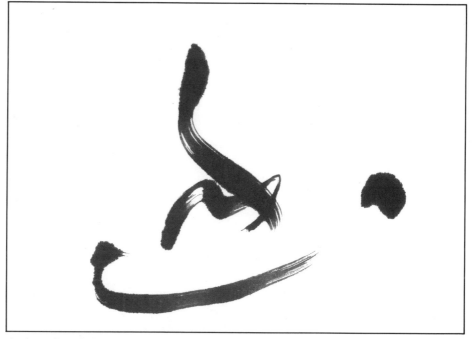

幽 (YŪ, *kasuka*), quiet beauty, faint: written to evoke the image of a sailing ship. Light ink.

"Quiet beauty" written in Cursive Script by Xiangju Shu (1259–1302).

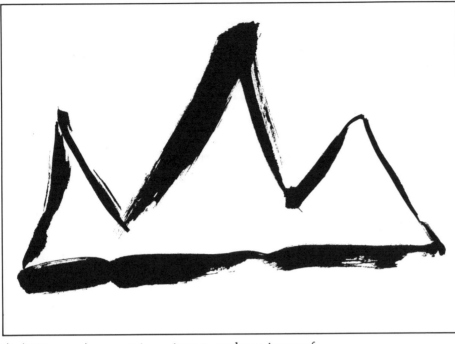

山 (SAN, *yama*), mountain: written to evoke an image of
the Japan alps.

"Mountain" as a pictograph from around 1000 B.C.

鹿 (ROKU, *shika*), deer: written to evoke the image of a
mighty stag.

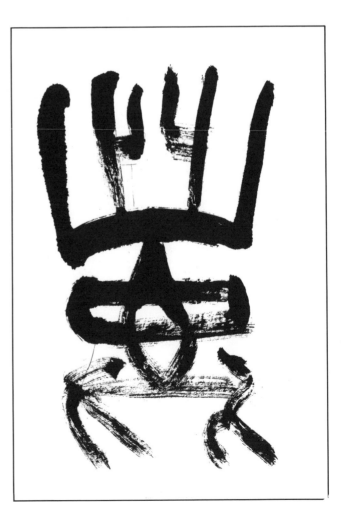

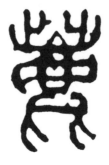

"Deer" as a pictograph from a stone-drum
inscription (422 B.C.).

花 (KA, *hana*), flower, blossom, bloom: written to suggest a budding flower in spring.

"Flower" written in Semicursive Script by Chu Suiliang (596–658).

波 (HA, *nami*), wave: written to suggest a towering wall of water.

"Wave" written in Cursive Script by Dong Qichang (1555–1636).

飛 (HI, *tobu*), flight, fly, soar: written in an aerobatic form.

"Flight" written in Cursive Script by Huaisu (725?–86?).

響 (KYŌ, *hibiki*), echo, vibration, sound: written so as to suggest a continuous echoing.

"Echo" written in Semicursive Script by Mi Youren (1072–1151).

LIST OF SHOPS WITH CALLIGRAPHY SUPPLIES

The following list has been compiled for aspiring calligraphers in the United States. It may be that not every store given here can supply *all* that is needed, but with this list as a start, and by searching out stores that have escaped our notice, you should be able to obtain the proper brushes, ink, and other things without, it is hoped, a great deal of difficulty. (Note that, under state headings, stores are arranged by zip code number.)

ALASKA
Artak
333 Irwin St
Mt View, AK 99508

ARIZONA
Uptown Paint & Art Supply
5034 N Central Ave
Phoenix, AZ 80512
Arizona Art Supply
3236 N 3rd St
Phoenix, AZ 85012
Simmons Art & Drafting Supplies
2620 W Broadway
Mesa, AZ 85202
House of Rice Store
3221 N Hayden Rd
Scottsdale, AZ 85251
The Shop of Art
26 E University Dr
Tempe, AZ 85281
Colorcraft
4759 E Speedway
Tucson, AZ 85712
Visible Difference Art Supply
116 S Beaver St
Flagstaff, AZ 86001

CALIFORNIA
KG Louie Co
432-446 Ginling Way
New Chinatown
Los Angeles, CA 90012
Kinokuniya Bookstores of America
106-123 S Weller St
Los Angeles, CA 90012
Books Nippan
532 W 6th St
Los Angeles, CA 90014
Kabuki Gifts & Import
11355 Santa Monica Blvd
W Los Angeles, CA 90025
LA Art Supply
2130 S Sawtelle Blvd #210
Los Angeles, CA 90025
HG Daniels Co
2543 W Sixth St
Los Angeles, CA 90057
Hakata China & Imports
4505 Centinela Ave
Los Angeles, CA 90066
World Supplies
3425 W Cahuenga Blvd
Hollywood, CA 90068
Yamato
1630 W Redondo Beach Blvd
Gardena, CA 90247
Nisei Oriental Gift Shop
15112 S Western Ave
Gardena, CA 90249
Graphic Media
13916 Cordary Ave
Hawthorne, CA 90250

Raleigh Art Shop
314 Manhattan Beach Blvd
Manhattan Beach, CA 90266
Ahe's Artist's Materials
608 Venice Blvd
Venice, CA 90291
Ashe Fine Art Supplies
608 Venice Blvd
Venice, CA 90291
Mittel's Art Center
828 Broadway
Santa Monica, CA 90401
Seibun-do
2210-A W Artesia Blvd
Torrance, CA 90504
Walser's
23377 Hawthorne Blvd
Torrance, CA 90505
Standard Brands Paint
4300 W 190th St
Torrance, CA 90509
Saylor Artist & Engineering
420 E 4th St
Long Beach, CA 90802
Atanley Swains Inc
536C N Glendale Ave
Glendale, CA 91206
Art Showcases
2101 Glendale Galleria
Glendale, CA 91210
Continental Art Supplies
7041 Reseda Blvd
Reseda, CA 91335
Cal Art Bookstore
24700 McBean Parkway
Valencia, CA 91355
Robsac Industries
6925 Tujunga Ave
N Hollywood, CA 91606
Vintage Art
1535-6 E Valley Parkway
Escondido, CA 92027
HG Daniels Co
1844 India St
San Diego, CA 92101
The Art Seller
435 University Ave
San Diego, CA 92103
Masako's Arts & Crafts
1339 Orange Ave #1
Coronado, CA 92118
Potpourri Artist's Supply
6930 Alvarado Rd
San Diego, CA 92120
Fine Art Store
8843 Clairemont Mesa Blvd
San Diego, CA 92123
Jenny's Oriental Gift Shop
11760 Dalehurst Rd
Sunnymead, CA 92388
Bud Ricker's Art Center
1277 N E St
San Bernardino, CA 92405

Plaza Pen & Art
7391H Warner Ave
Huntington Beach, CA 92647
Art Supply Warehouse
6909 Westminster Blvd
Westminister, CA 92683
Arbco Graphic Arts Center
1363 Donlon #6
Ventura, CA 93003
Orient Imports
813 State St
Santa Barbara, CA 93101
Roger's Art Materials
1427 San Andres
Santa Barbara, CA 93101
Laws Hobby Center
855 Marsh St
San Luis Obispo, CA 93401
Ginza Shop
150 Oliver St
Monterey, CA 93940
Deborah's Art
305 Forest Ave
Pacific Grove, CA 93950
Mikado
889 Santa Cruz Ave
Menlo Park, CA 94025
Flax's Artist's Materials
1699 Market St
San Francisco, CA 94103
Ginza
44 Peace Plaza
Japan Center
San Francisco, CA 94115
JC Trading (Mikado)
1737 Post St
Japan Center
San Francisco, CA 94115
Kinokuniya Bookstore of America
Japan Center
1581 Webster St
San Francisco, CA 94115
Pinocchio
Japan Center
22 Peace Plaza #250
San Francisco, CA 94115
Cando Artist's Materials
1541 Clement St
San Francisco, CA 94118
Japanese Tea Garden
532 Parker Ave
San Francisco, CA 94118
Franciscan Shop
1650 Holloway Ave
San Francisco, CA 94132
SF Art Institute Store
800 Chestnut St
San Francisco, CA 94133
University Art Center
267 Hamilton Ave
Palo Alto, CA 94301
Yamanaka Iseke Assocs
734 Maplewood Pl
Palo Alto, CA 94303
The Art Center
1327 4th St
San Rafael, CA 94403
Wong's Imports
2625 S El Camino Real
San Mateo, CA 94403
Artability
152 Village Sq
Orinda, CA 94563

The Artist Mart
1279 Boulevard Way
Walnut Creek, CA 94595

MacPherson/Fullerton
1327 Park Ave
Emeryville, CA 94608

Murasaki
6050 College Ave
Oakland, CA 94618

Hida Tool & Hardware
1333 San Pablo Ave
Berkeley, CA 94702

Wholesale Art Materials
PO Box 2632
Berkeley, CA 94702

The Ink Stone
2302 Bowditch
Berkeley, CA 94704

Nikko Art Shop
2320 Shattuck Ave
Berkeley, CA 94704

Michiko's Gifts & Arts
1841 Solano Ave
Berkeley, CA 94707

Sakai Art Studio
5966 Arlington Blvd
Richmond, CA 94805

Creative Merchandisers
785 Andersen Dr
San Rafael, CA 94901

Mill Valley Art Materials
433 Miller Ave
Mill Valley, CA 94941

Oriental Art Guild
16145 Jackson Oak Dr
Morgan Hill, CA 95037

Palace Art & Office Supply
2647 41 St Ave
Soquel, CA 95073

Wild Rose Artist Supplies
1326 Lincoln Blvd
Watsonville, CA 95076

Press'n Pen
2984 Union Ave
San Jose, CA 95112

Rileystreet
103 Maxwell Ct
Santa Rosa, CA 95401

Art Ellis Supply
2508 J St
Sacramento, CA 95816

Taylor's Art Center
2601 J Street
Sacramento, CA 95816

Sakura Gifts
2223 10th St
Sacramento, CA 95818

Art Drafting Engineering
122 Broadway
Chico, CA 95926

Ellis Art
1545 Placer St
Redding, CA 96001

COLORADO
Kobunsha Import
1255 19th St
Denver, CO 80206

Spivak Art Supply
230 Fillmore St
Denver, CO 80206

House of Wu
6117 East Colfax Ave
Denver, CO 80220

Guiry's Art Supplies
2484 S Colorado Blvd
Denver, CO 80222

Ziji
2019 10th St
Blouder, CO 80302

CSU Bookstore
Colorado State Univ
Fort Collins, CO 80523

Novis Frame Art Gallery
206½ N Tejon St
Colorado Springs, CO 80903

Art Depot
30 25th Rd
Grand Junction, CO 81505

CONNETICUT
Colormart
41 Broad St
Middletown, CT 06457

Hull's Hobbies
1203 Chapel St
New Haven, CT 06511

Cobbs Stationary & Art
2100 Dixwell Ave
Hamden, CT 06514

Paint N Frame
273 Greenwood Ave
Bethel, CT 06801

Barney's Place
107 Greenwich Ave
Greenwich, CT 06830

Art Supply Warehouse
360 Main Ave
Norwalk, CT 06851

Max's Art Supplies
68 Post Road E
Westport, CT 06880

DISTRICT OF COLUMBIA
Arise
6925 Willow Ave NW
Washington, DC 20012

FLORIDA
Craftsmen's Cove
2252 C Cove Blvd
Panama City Mall
Panama City, FL 32401

OFA Wholesale Art
946 N Mills Ave
Orlando, FL 32803

Pearl Paint
1033 E Oakland Park Blvd
Fort Lauderdale, FL 33334

County Art Center
1287 W Palmetto Park Rd
Boca Raton, FL 33432

Studio Shop
1401-A Cleveland St
Clearwater, FL 33515

Ringling School of Art
1111 27th St
Sarasota, FL 33580

Artcom
3710 W Kennedy
Tampa, FL 33609

Creative World
908 58th St N
St Petersburg, FL 33710

Hamm's Art Supplies
1756 Central Ave
St Petersburg, FL 33712

Marise Art Gallery
6506 Gateway Ave
Sarasota, FL 34231

GEORGIA
Artcraft
4316 Park Dr
Interstate Industrial Park
Norcross, GA 30093

Crest Art—Binders
PO Box 52815
Atlanta, GA 30355

HAWAII
The Palette
1164 Bishop St
Honolulu, HI 96813

Jonathan's Little Art Gallery
1777 Ala Moana Blvd
Honolulu, HI 96815

ILLINOIS
Hi-Land Art & Frame
668 Central Ave
Highland Park, IL 60035

Palatine Art Center
41 E Northwest Hwy
Palatine, IL 60067

Carlson Paint and Art
111 E Front St
Downtown
Wheaton, IL 60187

Goods of Evanston
714 Main St
Evanston, IL 60202

The Flax Company
180 North Wabash Ave
Chicago, IL 60601

Aiko's Art Materials
714 N Wabash Ave
Chicago, IL 60611

J Toguri Mercantile
851-853 W Belmont Ave
Chicago, IL 60611

Dick Blick Co
PO Box 1267
Galesburg, IL 61401

Prairie Book Arts Center
PO Box 725
Urbana, IL 61801

INDIANA
Multi Media Art Materials
6507 N College Ave
Indianapolis, IN 46220

Makielski Art Shop
117 North Main St
South Bend, IN 46601

United Supply
PO Box 10981
Ft Wayne, IN 46855

KANSAS
Kansas Union Bookstore
Univ of Kansas
Lawrence, KS 66045

KENTUCKY
St Matthews Blueprint & Supply
131 St Matthews Ave
Louisville, KY 40207

Shumakers
238 E Main St
Lexington, KY 40507

LOUISIANA
Dunbart Art Supply
4129 Magnolia St
New Orleans, LA 70115

MAINE
Artist & Craftsman Supply
380 Forest Ave
Portland, ME 04101

MARYLAND
Macco of Bethesda
8311 Wisconsin Ave
Bethesda, MD 20814

Slick Sweat
11005 Riverwood Dr
Potomac, MD 20854

Lipmans Art Shop
8209 Georgia Ave
Silver Spring, MD 20910

Creative Pastimes
2344B Columbia Mall
Columbia, MD 21044

Your Art's Desire
1008 Reisterstown Rd
Pikesville, MD 21208

Art Things
2 Annapolis St
Annapolis, MD 21401

Paper & Ink Book
15309-A Sixes Bldge Rd
Emmitsburg, MD 21727

MASSACHUSETTS
The University Bookstore
Student Union
Univ of Massachusetts
Amherst, MA 01002

WR Miele Distributing
333 Fuller St
Ludlow, MA 01056

Beyond Words Bookshop
Thornes Market
150 Main St
Northampton, MA 01060

Johnson's Bookstore
1379 Main St
Springfield, MA 01103

Brennan College Serv
45 Island Pond Rd
Springfield, MA 01118

Quill & Press
285 Main St
Acton, MA 01720

Johnson Art Materials
355 Newbury St
Boston, MA 02115

Harvard Square Art Center
17 Holyoke St
Cambridge, MA 02138

Yoshinoyas
36 Prospect St
Cambridge MA 02139

Graphic Art Center
1337 Beacon St
Brookline, MA 02146

The Paint Box
49 High St
Medford, MA 02155

Kobo Kamiya Inc
1280 Center St
Newton, MA 02159

The Minute Shop
9 Muzzey St
Lexington, MA 02173

Hyannis Art Supplies
675 Main St
Hyannis, MA 02601

Cape Cod Photo & Art Supply
PO Box 70
Orleans, MA 02653

Studio Shop of Provincetown
441 Commercial St
Provincetown, MA 02657

MICHIGAN
Greens of Rochester
429 Main St
Rochester, MI 48063

Ulrichs Books
549 E University Ave
Ann Arbor, MI 48104

Creative World
349 Briarwood Circle
Briarwood Mall
Ann Arbor, MI 48108

Northwest Blue Print & Supply
13450 Farmington Rd
Livonia, MI 48150

Silver-Lead Paint
PO Box 17009
Lansing, MI 48901

Downtown Art Supply
210 Museum Dr
Lansing, MI 48933

Labadies Arts
240 W Michigan Ave
Kalamazoo, MI 49007

Saito Gallery
2211 Saginan Rd SE
Grand Rapids, MI 49506

Creative World
100 Woodland Mall
3167 28th St SE
Grand Rapids, MI 49508

De Youngs
234 E Front St
Traverse City, MI 49684

MINNESOTA
Pendragons
862 Farrmount
St Paul, MN 55105

Wet Paint
1692 Grand Ave
St Paul, MN 55105

Yamato Import
320 Marquette Ave
Minneapolis, MN 55401

Artsign Materials
2501 26th Ave S
Minneapolis, MN 55406

White Oak Gallery
3939 E 50th St
Edina, MN 55424

Wild Crane Studios
2345 Hemlock Lane
Plymouth, MN 55441

A & E Supply
210 W Michigan St
Duluth, MN 55802

MISSOURI
Artmart
2355 S Hanley Rd
St Louis, MO 63144

AL J Bader Co
PO Box 7
St Louis, MO 63188

Michael's
2155 Zumbehl
St Charles, MO 63303

The City Art Store
1306 W 39th St
Kansas City, MO 64111

National Art Supply
3150 Mercier
Suite 689
Kansas City, MO 64111

MONTANA
The Ink Spot and Graphic Supply
26 N Last Chance Gulch
Helena, MT 59601

NEBRASKA
Standard Blue
10011 J St
Omaha, NB 68127

NEVADA
Dick Blick Co
PO Box 521
Henderson, NV 89015

NEW HAMPSHIRE
EW Poore Color Center
87 Elm St
Manchester, NH 03101

Bean's Art Store
38 S Main St
Hanover, NH 03755

Duke's Art Store
10 Allen St
Hanover, NH 03755

Tech Products
PO Box 1175
Portsmouth, NH 03801

NEW JERSEY
AKI Oriental Food
1635 Lemoine Ave
Fort Lee, NJ 07024

Pearl Arts & Crafts
PO Box 888
Woodbridge, NJ 07095

NEW MEXICO
Artisan/Santa Fe
717 Canyon Rd
Santa Fe, NM 87501

China Friendship Trade
Box 1688
Taos, NM 87571

NEW YORK
New York Central Art Supply
62 Third Ave
New York, NY 10003

Ozora
238 E 6th St
New York, NY 10003

Tribeca Artist Materials
142 Chambers St
New York, NY 10007

Eastern Artist & Drafting
5 West 22nd St
New York, NY 10010

AI Friedman Inc
44 West 18th St
New York, NY 10011

Five Eggs
436 W Broadway
New York, NY 10012

Chinatown Trading
28 Pell St
New York, NY 10013

Pearl Paint
308 Canal St
New York, NY 10013

Glasner Art Supply
17 E. 37th St
New York, NY 10016

Menash Inc
462 7th Ave
New York, NY 10018

Books Nippon
115 W 57th St
New York, NY 10019

Lee's Art Shop
220 W 57th St
New York, NY 10019

Kinokuniya Bookstores of America
10 W 49th St
New York, NY 10020

Asia Society Bookstore
725 Park Ave
New York, NY 10021

Arthur Brown & Bros
2 West 46th St
New York, NY 10036

Zen Oriental Bookstore
521 Fifth Ave
New York, NY 10177

Maijiya
2642 Central Park Ave
Yonkers, NY 10710

The Art & Blueprint Co
7 Memorial Hwy
New Rochelle, NY 10801

Graphic Art Mart
321 Dekalb Ave
Brooklyn, NY 11205

Jerry's Artarama
248-12 Union Turnpike
Bellerose, NY 11426

Pearl Paint
2411 Hempstead Turnpike
East Meadow, NY 11554

Clancy Enterprises
48 Dcabot St
W Babylon, NY 11704

Japan Home Art
164 E Main St
Bayshore, NY 11706

Crafts Plus
Stuyvesant Plaza
Albany, NY 12203

Kristt Co
PO Box 548
Monticello, NY 12701

Soave Faire
449-451 Broadway
Saratoga Springs, NY 12866

Art Tree
1493 Hertel Ave
Buffalo, NY 14216

Rochester Institute of Technology
Campus Connection
PO Box 9887
Rochester, NY 14623

OHIO

Color Haven
4105 Secor Rd
Toledo, OH 43623

Toledo Museum of Art
PO Box 1013
Toleda, OH 43697

Mentor Office Supply
7450 Center St
Mentor, OH 44060

Multicraft
8601 Carnegie Ave
Cleveland, OH 44106

Noble Photo & Art
20307 Van Aken Blvd
Shaker Heights, OH 44122

All Media Material
417 E Main St
Campus Center Plaza
Kent, OH 44240

University Bookstore
Kent State Univ
Kent, OH 44242

Ruppels
677 Carroll St
Akron, OH 44304

Art-Cetera
Howland Plaza
8246 E Market St
Warren, OH 44484

Suders Art Store
1309 Vine St
Cincinnati, OH 45210

OREGON

C2F Inc
PO Box 1417
Beaverton, OR 97075

Art Media
902 SW Yamhill
Portland, OR 97205

Pacific Stationary
PO Box 20669
Portland, OR 97230

University of Oregon Bookstore
PO Box 3176
Eugene, OR 97403

Shibumi Trading
PO Box 1-F
Eugene, OR 97440

Train Gallery
1951 Redwood Ave
Grants Pass, OR 97526

PENNSYLVANIA

Nittany Quill
111 South Fraser St
Sate Colledge, PA 16801

South Street Art Supply
515 Spring Garden St
Philadelphia, PA 19123

Ingalls Fine Craft & Art
5519 Greene St
Philadelphia, PA 19144

RHODE ISLAND

Oakes On The Hill
12 Thomas St
Providence, RI 02903

Rhode Island School of Design
 Bookstore
30 N Main St
Providence, RI 02903

TEXAS

Classical Martial Arts of Japan
606 Adams
Duncanville, TX 75137

Chinese Paint Brush
3028 Fondren Dr
Dallas, TX 75205

Mullican Art Supply
6916 Snider Road Plaza
Dallas, TX 75205

Paper Routes
4112 Commerce St
Dallas, TX 75226

Southwest Art Center
706 Preston Forest
Shopping Center
Dallas, TX 75230

Flying Pen
3017 Lubbock
Fort Worth, TX 76109

Canary Hill
3033 Fountain View Dr
Houston, TX 77057

Craft Corner
502 W 30th
Austin, TX 78705

Things Oriental
1519 W Koenig Lane
Austin, TX 78756

UTAH

Phillips Gallery
444E 2nd S
Salt Lake City, UT 84111

Univ of Utah Bookstore
Univ of Utah Campus
Salt Lake City, UT 84112

VERMONT

The Bookstore
Rennington College
Bennington, VT 05201

VIRGINIA

JF Thomas Co
5825 Leesburg Pike
Baileys Crossroad, VA 22041

Color Wheel
1347 Chainbridge Rd
Mclean, VA 22101

Eastern Art Supply
5706 E General Washington Dr
Alexandria, VA 22312

Sumi-e Floral Center
PO Box 87
White Stone, VA 22578

Abel Frame & Art Supply
Aragona Shopping Center
4848-12 Virginia Beach Blvd
Virginia Beach, VA 23462

Mish Mish
204 Draper Rd
Blackburg, VA 24060

WASHINGTON

Seattle Art
1816 8th Ave
Seattle, WA 98101

Opus 204
225 Broadway E
Seattle, WA 98102

Uwajimaya
6th Ave S
Seattle, WA 98104

Shiga's One World Shop
4306 University Way
Seattle, WA 98105

University Bookstore
4326 University Way NE
Seattle, WA 98105

Daniel Smith Inc.
4130 1st Ave S
Seattle, WA 98134

Tacoma Community College Bookstore
5900 S 12th St
Tacoma, WA 98465

Spokane Art Supply
N 1303 Monroe St
Spokane, WA 99201

Ra-Tels
811 W Garland
Spokane, WA 99205

WEST VIRGINIA

Barry's Office Service
1370 University Ave
Morgantown, WV 26505

WISCONSIN

Palette Shop
342 N Water St
Milwaukee, WI 53202

Sax Arts & Crafts
PO Box 2002
Milwaukee, WI 53202

Nasco
901 Janesville Ave
Fort Atkinson, WI 53538

INDEX

完